Dogs
How to Draw Them

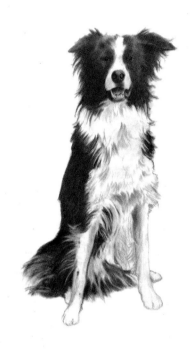

I would like to dedicate this book to my Mum, who sadly passed away on April 4 2001. I will miss her enthusiasm and encouragement.

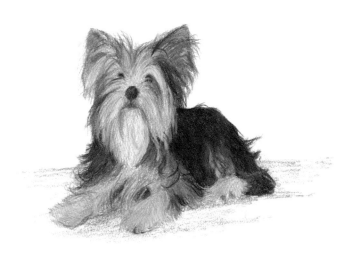

Dogs
How to Draw Them

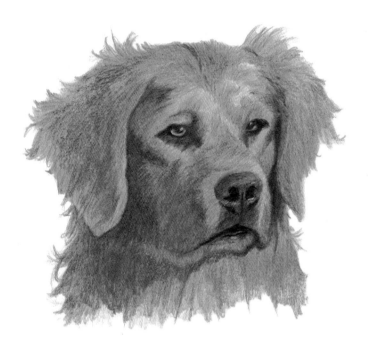

Melvyn Petterson

NORTH LIGHT BOOKS
Cincinnati, Ohio

First published in Great Britain in 2002 by
Collins & Brown Limited
64 Brewery Road
London N7 9NT

A member of the Chrysalis Group plc

First published in North America
in 2002 by North Light Books
an imprint of F&W Publications
4700 East Galbraith Road
Cincinnati, Ohio 45236

Illustrations by Melvyn Petterson
Edited by Ian Kearey
Project managed by Emma Baxter
Designed by Alison Shackleton
Photography by George Taylor

1 3 5 7 9 8 6 4 2

Reproduction by Classicscan Pte. Ltd, Malaysia
Printed and bound by Tat Wei Printing Packaging Pte Ltd, Singapore

ISBN 1-58180-198-X

Library of Congress Cataloging-in-Publication Data is available.

CONTENTS

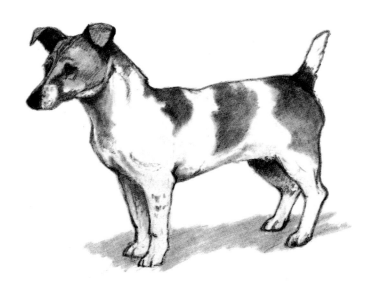

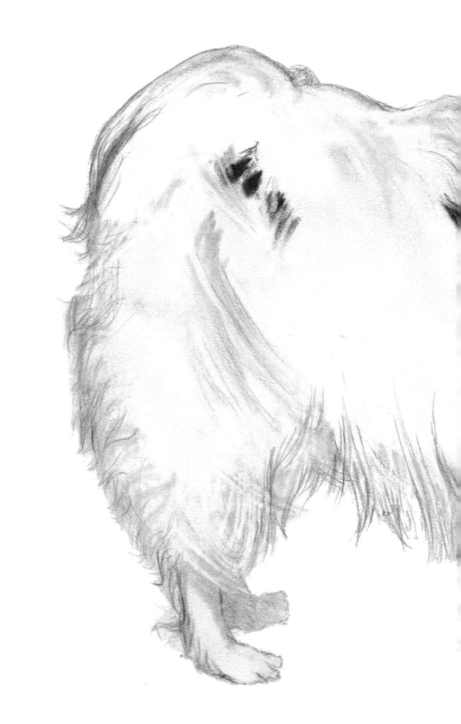

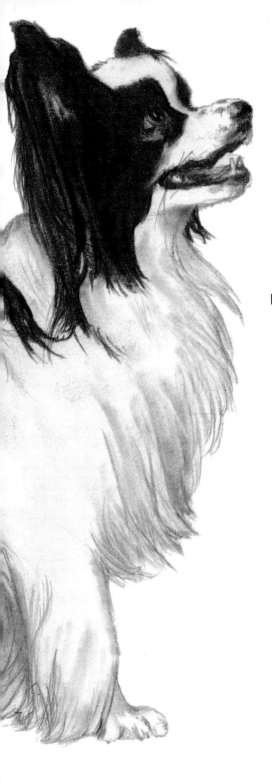

BASIC SHAPES

Before you start to draw dogs with accuracy, you need to understand at least the basics of how their skeletons and muscles form the framework for what we see. This chapter looks at the wildly different proportions and body shapes found in dogs, from miniature to giant.

DOG SHAPES

Of all domesticated mammals, dogs have the greatest variations in their shape and size: from a Chihuahua to a Wolfhound is a huge leap, as is the difference between a short-legged Dachshund and a lanky Whippet. The shape can also be disguised by coats – just think of a Hungarian Puli or Italian Bergamasco, where you have no idea what lies beneath that long corded coat.

All this variety makes drawing dogs a real challenge. The only way to successful drawings is to work from observation and not make assumptions; and this starts with working out from the bone and muscle structure. Of course, you don't need to be an expert on anatomy, but a little basic knowledge of the features common to all *Canes familiaris* can lay the groundwork for what follows – and this is particularly true if you have to make use, as do most artists who draw animals, of reference materials such as photographs.

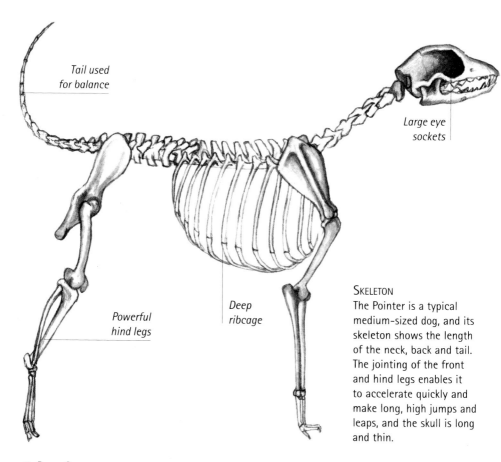

Tail used
for balance

Large eye
sockets

Powerful
hind legs

Deep
ribcage

SKELETON
The Pointer is a typical medium-sized dog, and its skeleton shows the length of the neck, back and tail. The jointing of the front and hind legs enables it to accelerate quickly and make long, high jumps and leaps, and the skull is long and thin.

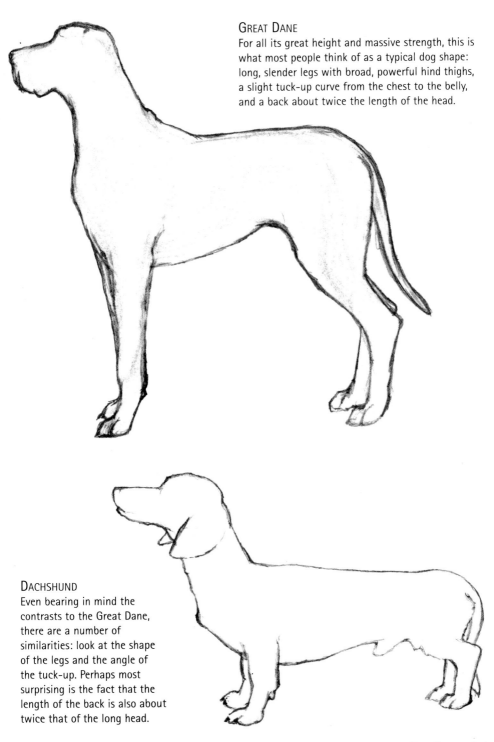

GREAT DANE

For all its great height and massive strength, this is what most people think of as a typical dog shape: long, slender legs with broad, powerful hind thighs, a slight tuck-up curve from the chest to the belly, and a back about twice the length of the head.

DACHSHUND

Even bearing in mind the contrasts to the Great Dane, there are a number of similarities: look at the shape of the legs and the angle of the tuck-up. Perhaps most surprising is the fact that the length of the back is also about twice that of the long head.

Proportions

The main problem both owners and artists tend to have with dog proportions is judging how big that appealing little bundle is going to grow up to be. Unless you are sure that a puppy is of a recognized breed, you can never be certain how they will turn out. However, a good indicator is that large paws on a puppy are nearly always a sign that it will grow into a large dog.

Even with classifiable breeds, there is no easy formula for dealing with proportions, as the variations are immense: you can reckon on English, Irish and Gordon Setters being pretty well the same, but the quite close Cocker, Water and Springer Spaniels show many more differences. The drawings here show you typical examples, but you have to take each case as it comes.

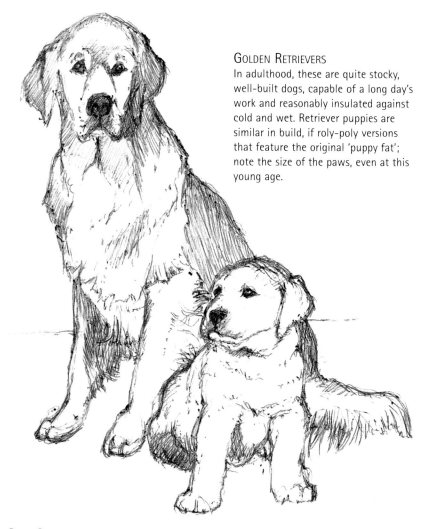

Golden Retrievers
In adulthood, these are quite stocky, well-built dogs, capable of a long day's work and reasonably insulated against cold and wet. Retriever puppies are similar in build, if roly-poly versions that feature the original 'puppy fat'; note the size of the paws, even at this young age.

Rough Collies

The ears, eyes and nose may be the same, but the puppy has none of the lean, elegant wiriness of the adult dog. Even the coats are different: the adult's long hair is drawn with sweeps of watercolour pencils, the puppy's short coat with spiky marks.

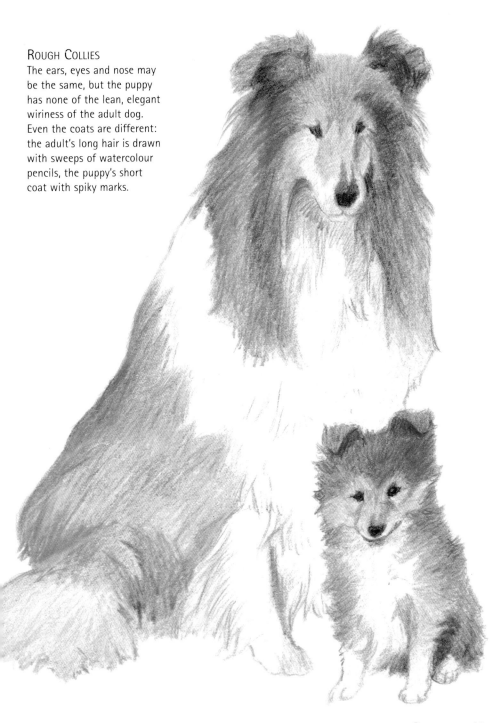

LARGE DOGS

The challenge with drawing large dogs is to capture their sheer size and bulk. One way to give an indication of the massive heads, bodies and legs is to sketch in some of the setting, thus providing a sense of context and space; if you do this, make sure that you are accurate, otherwise you may unwittingly achieve a Magritte-like, surreal other-worldliness.

A good exercise is to practise drawing just the outlines of the dog, working in a quick medium like charcoal or pencil; you can soon see whether your lines describe the bulk and volume.

Often the physical presence of a large dog is brought out in its fitness for a particular purpose – so look to bring this out in your drawings.

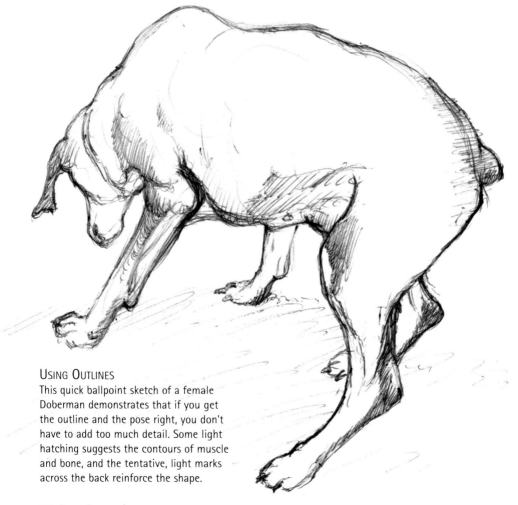

USING OUTLINES
This quick ballpoint sketch of a female Doberman demonstrates that if you get the outline and the pose right, you don't have to add too much detail. Some light hatching suggests the contours of muscle and bone, and the tentative, light marks across the back reinforce the shape.

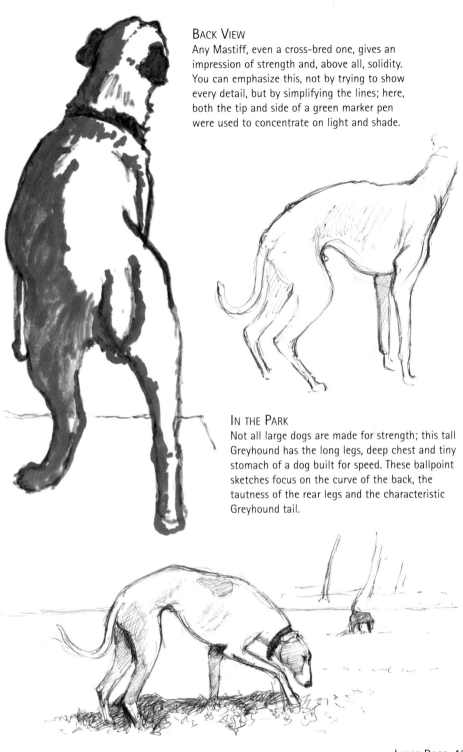

BACK VIEW

Any Mastiff, even a cross-bred one, gives an impression of strength and, above all, solidity. You can emphasize this, not by trying to show every detail, but by simplifying the lines; here, both the tip and side of a green marker pen were used to concentrate on light and shade.

IN THE PARK

Not all large dogs are made for strength; this tall Greyhound has the long legs, deep chest and tiny stomach of a dog built for speed. These ballpoint sketches focus on the curve of the back, the tautness of the rear legs and the characteristic Greyhound tail.

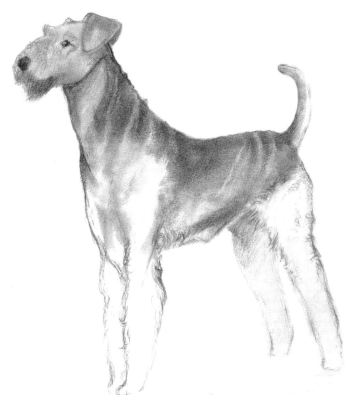

TALL TERRIER
This quick sketch of an Airedale Terrier shows the breed's long neck and legs, stumpy tail and square muzzle, complete with 'beard'. The stance was drawn lightly to establish the dimensions and proportions, and soft and hard pencils were used for the outline, markings and details respectively.

BUILT FOR STRENGTH
With a powerful, deep chest and a low centre of gravity, the Siberian Husky is perfectly adapted to pulling heavy loads over great distances. There is no room for reworking with a ballpoint pen, so make tentative marks at first, and retain them in places for their energy.

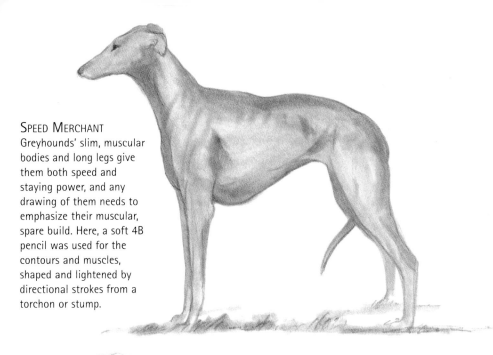

SPEED MERCHANT
Greyhounds' slim, muscular bodies and long legs give them both speed and staying power, and any drawing of them needs to emphasize their muscular, spare build. Here, a soft 4B pencil was used for the contours and muscles, shaped and lightened by directional strokes from a torchon or stump.

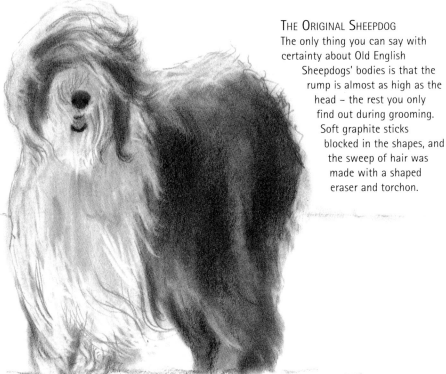

THE ORIGINAL SHEEPDOG
The only thing you can say with certainty about Old English Sheepdogs' bodies is that the rump is almost as high as the head – the rest you only find out during grooming. Soft graphite sticks blocked in the shapes, and the sweep of hair was made with a shaped eraser and torchon.

SMALL, TOY AND MINIATURE DOGS

This heading describes an even greater variety than 'large dogs', because it includes both those that are smaller versions of big ones, such as Miniature Schnauzers or Toy Poodles, which have identical but scaled-down legs, and breeds such as Dachshunds or Yorkshire Terriers, whose legs tend to be naturally short or even stumpy.

The temptation with these small breeds is to make drawings that concentrate on the details of the tiny face and intricate hair, at the cost of getting the proportions and shape right. Even an Affenpinscher or Griffon Bruxellois, all charming face and wild hair, must have the right dimensions: as with large dogs, you should consider including some surroundings to provide necessary perspective, and practise drawing with a large, fast medium, such as a big crayon or charcoal stick.

PAPILLON
For all their lack of size, small dogs have an abundance of lively character. The body, drawn with a soft 4B pencil and torchon, and head and details, marked with a B pencil, bring out the personality of this 'butterfly' dog, named from the wing-like fur falling from its ears.

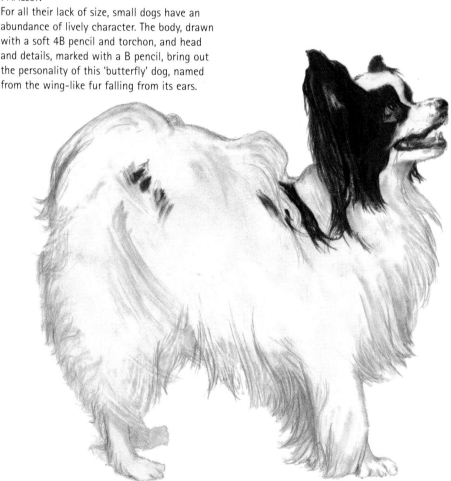

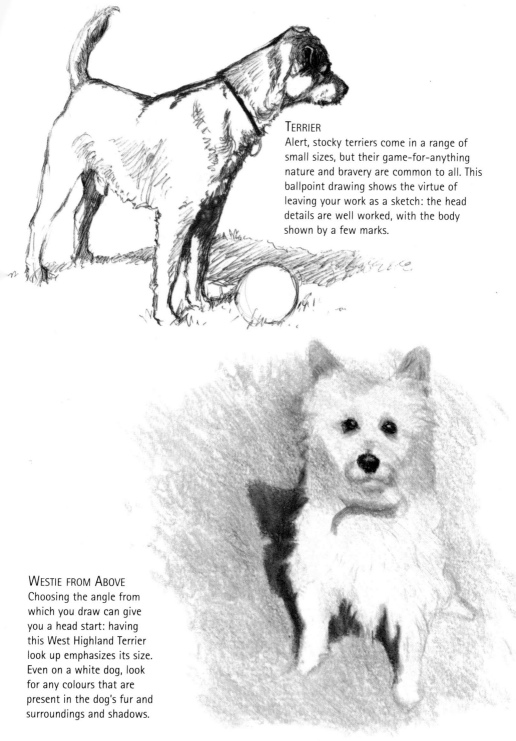

TERRIER

Alert, stocky terriers come in a range of small sizes, but their game-for-anything nature and bravery are common to all. This ballpoint drawing shows the virtue of leaving your work as a sketch: the head details are well worked, with the body shown by a few marks.

WESTIE FROM ABOVE

Choosing the angle from which you draw can give you a head start: having this West Highland Terrier look up emphasizes its size. Even on a white dog, look for any colours that are present in the dog's fur and surroundings and shadows.

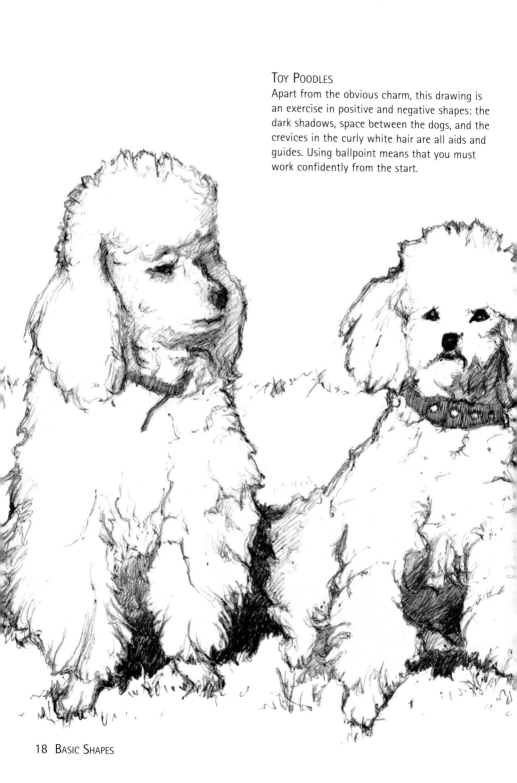

TOY POODLES

Apart from the obvious charm, this drawing is an exercise in positive and negative shapes: the dark shadows, space between the dogs, and the crevices in the curly white hair are all aids and guides. Using ballpoint means that you must work confidently from the start.

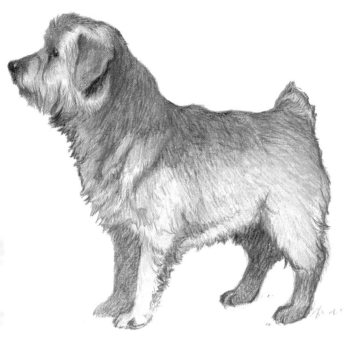

NORFOLK TERRIER

Looked at in isolation, this dog's body could belong to a larger breed – it is only with the short legs that we realise its true dimensions. By patiently building up from light to dark colours, just three shades of ochre and a sepia watercolour pencil were needed.

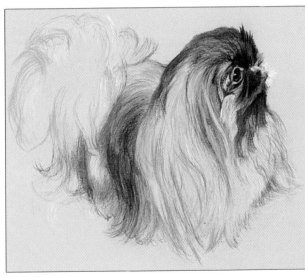

PEKINESE

Long-haired small dogs give you the opportunity to explore colour and hair direction, even if the feet are completely hidden. In this watercolour pencil study, the detailed, short strokes that define the head are in complete contrast to the looser, freer work on the exuberant tail.

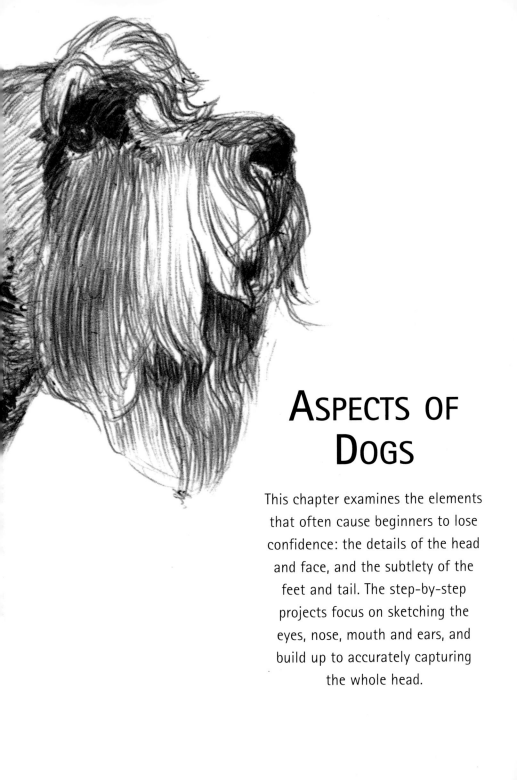

ASPECTS OF DOGS

This chapter examines the elements
that often cause beginners to lose
confidence: the details of the head
and face, and the subtlety of the
feet and tail. The step-by-step
projects focus on sketching the
eyes, nose, mouth and ears, and
build up to accurately capturing
the whole head.

Head Shapes

As discussed in the last section, there is no one head shape that is definitive – but there are features common to all but the flat-faced breeds: the long muzzle curved down from the forehead is the legacy of the ancestor wolf, and the placing and shape of the eyes are similar. Beyond that, variety and individualism are a great advantage to the artist: if you have to look hard to find uniqueness, you are less likely to fall back on assumptions about head shapes that are not accurate.

It can be helpful sometimes to make studies of dog heads using media that you are not used to: the discipline involved in controlling and getting the best out of a new medium can aid concentration and sharpen your powers of observation.

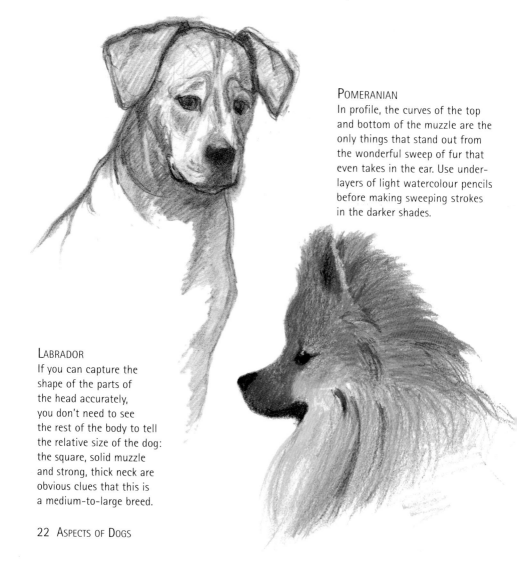

POMERANIAN
In profile, the curves of the top and bottom of the muzzle are the only things that stand out from the wonderful sweep of fur that even takes in the ear. Use under-layers of light watercolour pencils before making sweeping strokes in the darker shades.

LABRADOR
If you can capture the shape of the parts of the head accurately, you don't need to see the rest of the body to tell the relative size of the dog: the square, solid muzzle and strong, thick neck are obvious clues that this is a medium-to-large breed.

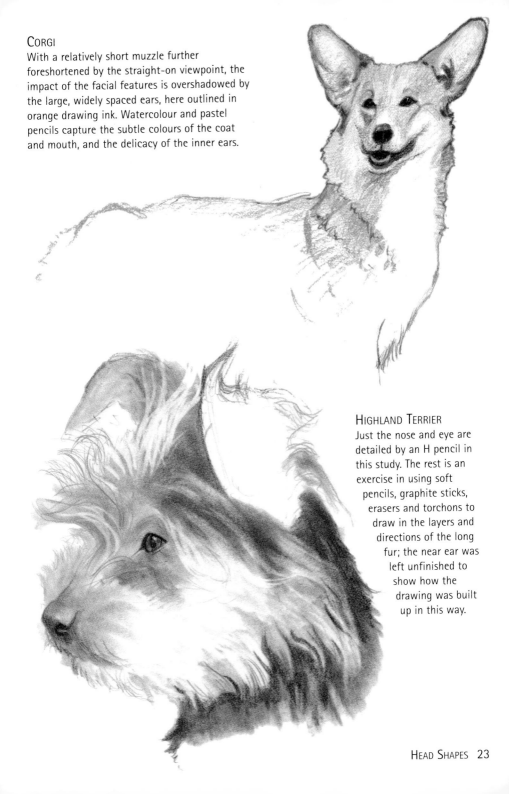

CORGI

With a relatively short muzzle further foreshortened by the straight-on viewpoint, the impact of the facial features is overshadowed by the large, widely spaced ears, here outlined in orange drawing ink. Watercolour and pastel pencils capture the subtle colours of the coat and mouth, and the delicacy of the inner ears.

HIGHLAND TERRIER

Just the nose and eye are detailed by an H pencil in this study. The rest is an exercise in using soft pencils, graphite sticks, erasers and torchons to draw in the layers and directions of the long fur; the near ear was left unfinished to show how the drawing was built up in this way.

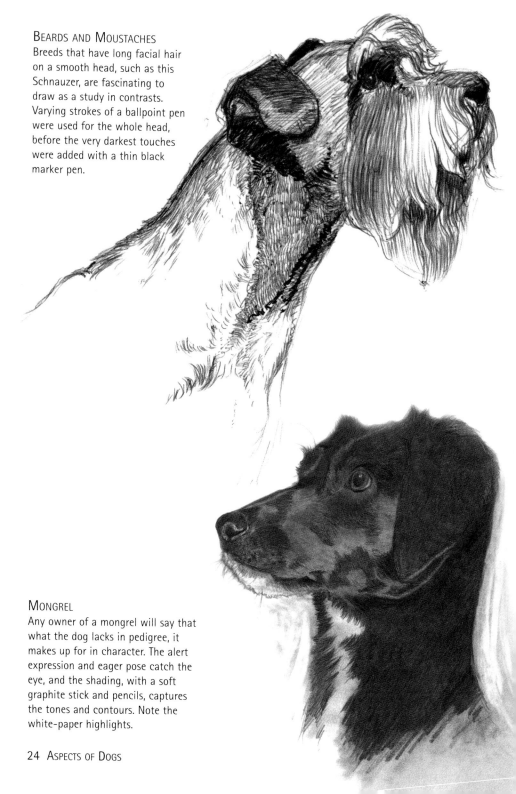

BEARDS AND MOUSTACHES

Breeds that have long facial hair on a smooth head, such as this Schnauzer, are fascinating to draw as a study in contrasts. Varying strokes of a ballpoint pen were used for the whole head, before the very darkest touches were added with a thin black marker pen.

MONGREL

Any owner of a mongrel will say that what the dog lacks in pedigree, it makes up for in character. The alert expression and eager pose catch the eye, and the shading, with a soft graphite stick and pencils, captures the tones and contours. Note the white-paper highlights.

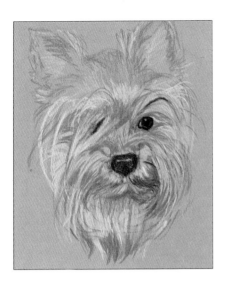

YORKSHIRE TERRIER
The tinted paper provides a strong colour base for this characterful head, drawn mostly with watercolour pencils and finished with pencil and brown marker pen. The long sweeps of hair obscure the shape of the lower part of the head, but this must still be implied at the least.

COCKER SPANIEL
In this study, H and HB pencils were used for the head, and the contours were added using a torchon to spread and blend the graphite, but the ears – normally the most characteristic feature – were left un-finished on purpose, to bring the focus onto the rest of the head.

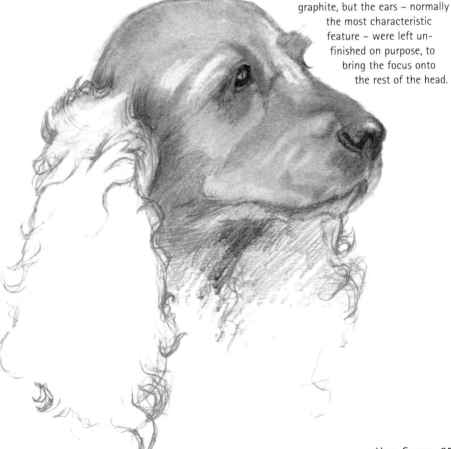

QUICK HEAD STUDIES

Whatever the breed, the best way to learn how to draw a head is by drawing a head. A tired, sleepy dog will usually give you the best opportunity, and these pencil studies of a sleeping Golden Labrador were made in just such a situation, and show that some poses were held long enough only to set down the basic shapes, while others enabled some shading and detail to be added. It can be a good idea to concentrate on working from as many angles as you can, thus producing lots of accurate sketches, rather than spending all the available time trying to get one perfect view.

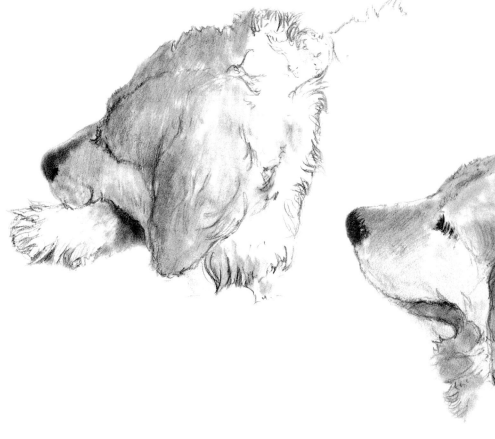

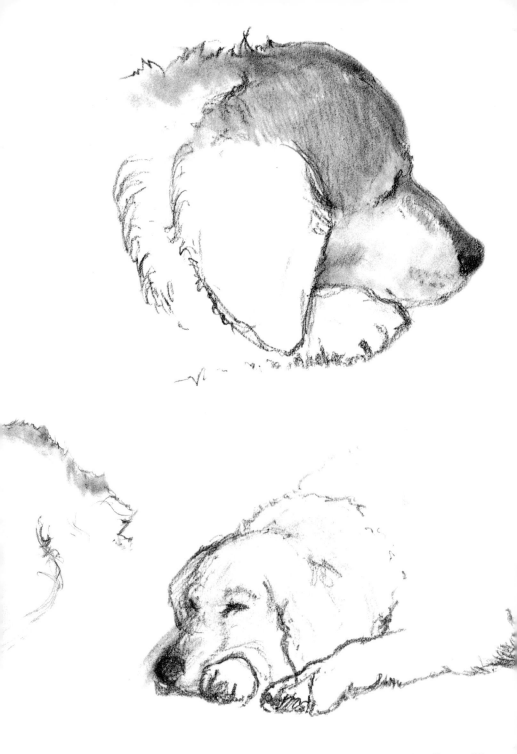

EYES

Dogs' eyes are their most eloquent feature, whether they be button eyes, drooping eyes, or even hardly visible eyes behind a curtain of hair. Eagerness, intelligence and loyalty shine in them, and catching them correctly is the key to successful drawings. One bugbear to look out for here is placing the highlight accurately – make it part of the very first exploratory marks you make.

Given the variety of shapes, colours, sizes, position on the head and pupil size, once you have established the constituent parts of the eye and how to observe and set them down, you can use one or both eyes as the starting point for portraits and work outwards from them. All the whole-head studies and portraits in this book were made using this method.

THE MORNING AFTER
With loose, drooping skin around them and bloodshot whites, Basset Hounds' and Bloodhounds' eyes have a sad, melancholy appearance. As in this sketch, relate the colour of the bloodshot veins to that of the surrounding hair, and keep it within the bounds of probability and physical reality.

TWO LOVELY BLACK EYES
There may be iris colours present, but in this Chihuahua, as with most other toy and miniature dogs, you wouldn't know it for sure. Don't be tempted to fill in the area around the highlight with solid black from the start, but build up the colour, perhaps over grey or blue.

DRAWING EYES

This upward glance from a sable-and-red Border Collie pup is not only very appealing, but also shows the whites of the eyes. I used pastel pencils to bring out the colours.

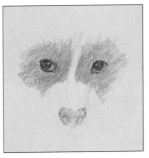

CANINE OR HUMAN?

However much a dog's eyes may remind you of a human expression, try not to draw them in imitation of your own. Even at this angle, with well-defined eyebrows, the shape, colour and amount of white showing are all different to ours, so observe and portray them accurately.

1 Use light marks to position the outline, iris and pupil of one eye, then draw guide lines to establish the distance to the other. A light shading of hair colour helps to fix the eyes' hue. Colour in the pupils, leaving the highlights white.

2 Add guide lines, sketch the nose, then build up the colours around the eyes, following the contours and directions of the eyebrows. Next, darken the outlines of the eyes and add specks of red in the corners.

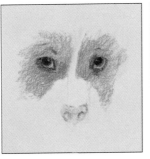

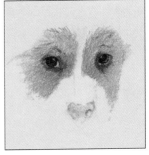

EYE COLOURS

Most dogs' irises are variations of brown, but this is by no means always the case: Spitzes and Huskies, among others, have pale grey, almost white, eyes that recall their vulpine cousins, and Catahoula Hog (or Leopard) Dogs can have eyes in contrasting colours, as shown here.

3 Carefully blacken the pupils using a sharp pencil. Darken the brown immediately around the eye socket, then use dark brown (not black) to build up the eyebrows lightly. Use the side of the pencil to shape the sides of the head.

4 Use the sharp black pencil to define the rim around each iris, then add touches of umber around the eyes and at the top of the nose. Work outwards all the time, adding orange and umber to fix the colour, and extra dark marks on the eyebrows.

Long Noses

As with most canine facial features, the term 'long noses' means more than just one set size and shape: the slender muzzle of a Rough Collie, Saluki or Greyhound, and the broader nose of a Rottweiler, Labrador or Great Dane all fall under this heading. More unusual shapes, such as the 'Roman nose' of a Bull Terrier, can also be within the classification. The unifying factor is that they all protrude outwards from the face and all have a defined muzzle ridge.

Things to look out for when drawing long noses are the distance away from the eyes, the shape of the ridge – which is unlikely to be straight – and the lay of the hair, which can fall in any direction. Make studies of the colour and curve of the nose itself.

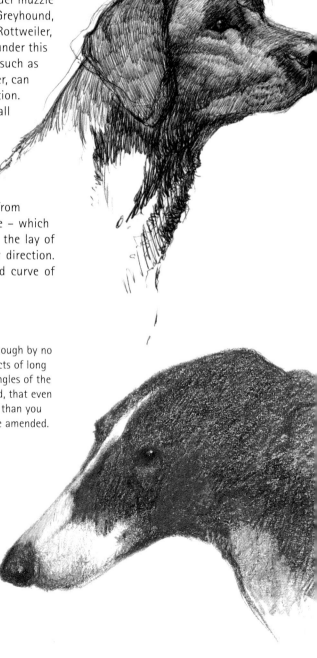

Black Labrador
This ballpoint working drawing, although by no means finished, shows up two aspects of long noses in particular: first, that the angles of the nose can be quite sharp; and second, that even in profile, the muzzle may be wider than you had anticipated and may need to be amended.

Greyhound
Along with Afghans, Rough Collies and Salukis, Greyhounds' noses are probably the longest canine ones. This pastel study emphasizes the sleekness of the muzzle and how there may be hardly any definition between it, the eyebrows and the top of the head in dogs developed for speed.

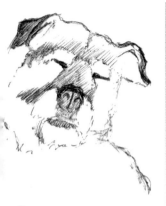

DRAWING LONG NOSES

The well-defined shapes and colours of the nose of a Brittany, a French hunting dog, suggest mixed media: I used diluted inks, pastels and a felt-tip pen in this exercise.

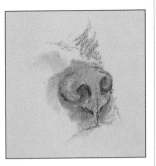

PERSPECTIVE

Depending on the angle that you view and draw it from, even a longish nose can appear to be short or even snub. The actual shape of the nose, however, will be different from a genuinely short one – see the pug nose on page 33 for a comparison.

1 *Make up diluted washes of ink and test them on scrap paper until they are right. Use the lightest wash to make pen marks that define the whole nose and shape of the nostrils, including the central cleft that runs downwards.*

2 *Add a few lines for the mouth and the muzzle ridge from the eyes. Lightly put on some colour with pastels, then use a torchon to spread the dust. Blue is good for highlights, and a touch of black deepens the nostrils.*

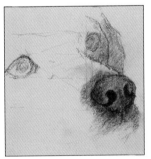

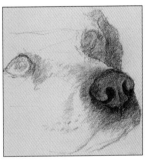

3 *Use pen and ink for the lower jaw and right-hand outline, before building up the pastels across the lower nose and nostrils. A dark brown felt-tip defines the nostrils, then blend purple pastel with a torchon across the upper nose. Add the eyes and far ear.*

4 *Use a very light blue for the moist highlights on the nose, then add the lightest tones around it. Blend light-brown marks to show the distance along the muzzle, following the many directions of the short hairs, which may also be brindled.*

Short Noses

Drawing a short nose is not simply a matter of setting down a long nose shape, only right between the eyes. Many decades of selective breeding have meant that the whole shape of a short, flat canine nose is different to that of a long one – nostrils, outline, cleft, details and all – and the upturned nose of an Affenpinscher is in contrast with the broad nose of a Boxer.

Without a muzzle ridge to look for, here your attention should be on the immediate surroundings of the nose; in some cases, as in the step-by-step example on the page opposite, the nose and forehead are a series of triangles, while in others there may be prominent, rounded cheekbones. A useful exercise is to draw a series of short noses in profile.

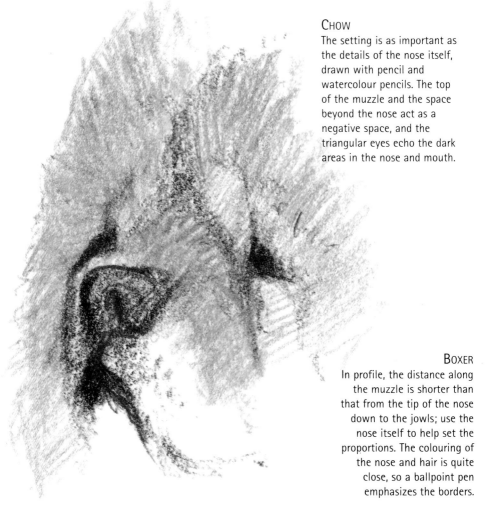

Chow
The setting is as important as the details of the nose itself, drawn with pencil and watercolour pencils. The top of the muzzle and the space beyond the nose act as a negative space, and the triangular eyes echo the dark areas in the nose and mouth.

Boxer
In profile, the distance along the muzzle is shorter than that from the tip of the nose down to the jowls; use the nose itself to help set the proportions. The colouring of the nose and hair is quite close, so a ballpoint pen emphasizes the borders.

DRAWING SHORT NOSES

Noses don't come much shorter than a pug's. This exercise is all about triangles, and I used graphite powder and sticks, plus torchons to spread the dust around and remove it.

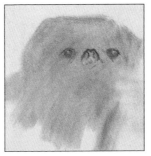

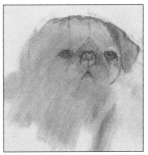

1 *Use a clean tissue or cloth to rub graphite powder into the tooth of the paper in the rough outline. Shape one eye with a graphite stick, then move across to the other eye via the top of the nose, almost on the same plane.*

2 *Add definition to the upper part of the nose, then draw in the triangle that rises to a peak above it. Build up the top of the head and one ear, following the contours of the hair and skull by spreading the graphite with a torchon.*

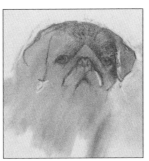

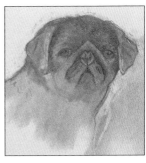

3 *As you start to darken the blackest parts with a small graphite stick, accentuate the three triangles: above the eyes, up to the nose, and mouth. Build these up from light to heavy, removing dust with the torchon as required. Add the other ear.*

4 *Finish the detail of the nose, making highlights with the torchon and getting the triangle shapes accurate. Suggest the bottom of the head, and deepen the shadows cast by the skin. Don't forget the whisker ends just below the nose.*

BULL MASTIFF
Don't fall into the trap of thinking that canine nostrils are a similar shape – they are all different. This sketch in dark sepia pencil uses tonal hatching to show up the fleshy part on the right of the nose, and the delicate curve of the nostrils.

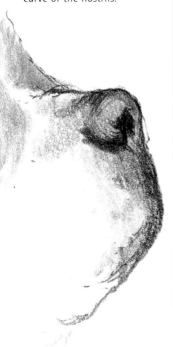

Mouths

This encompasses more than just the line of the mouth, but includes both upper and lower jaws, all the muzzle below the nose, and the tongue, teeth and gums, which can be very prominent in certain poses.

In certain loose-skinned breeds like the Bloodhound, Basset Hound or Shar Pei, the mouth includes long jowls and folds of skin; in short-nosed dogs such as Boxers, Boston Terriers and English Bulldogs, the emphasis is on the large lower jaw; and Pugs have arc-like cheeks similar to cats.

In all this variety, remember to look for the whiskers and their holes, and for any signs of brindling or greying around the jaw in older dogs. The pink colours of the tongue and gums can change depending on how hot or cold the dog is.

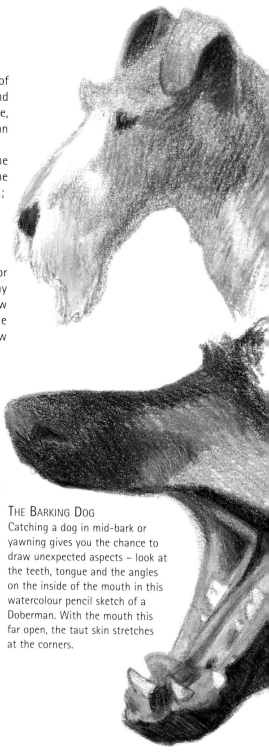

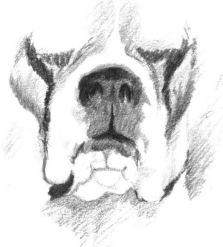

Downturned Mouth
The reputation for grumpiness that some breeds, such as Boxers, have is partly due to the shape of their mouths. For the artist, the fall of the jowls and the shapes made by loose skin in the lower jaw are challenges to observation and drawing techniques.

The Barking Dog
Catching a dog in mid-bark or yawning gives you the chance to draw unexpected aspects – look at the teeth, tongue and the angles on the inside of the mouth in this watercolour pencil sketch of a Doberman. With the mouth this far open, the taut skin stretches at the corners.

Hidden Mouth

Breeds such as Schnauzers and this Wire-haired Fox Terrier have mouths hidden under whiskers or beards, which give no indication of what is really underneath the long fur. This water-colour pencil drawing uses short hatched strokes to present both the hair and the rectangular, brick-shaped muzzle beneath.

Drawing Mouths

The loose skin around a Basset Hound's mouth drops away from the jaw, giving a good view of the gums and teeth. I used waxy coloured pencils for the variety of tones and colours.

1 *Sketch in the shapes of the top of the mouth and the tongue, including the central line, and then shade across to suggest the shadow areas and contours. Shape the prominent tooth and lower jaw, then add the nose to give the mouth a context.*

2 *Add the gum line and back teeth, checking that the distances between them are accurate. Bring in the corners of the mouth, paying attention to folds and creases. Add light strokes of pink for the tongue and gums, keeping them the same shade for now.*

3 *Strengthen the dark areas at the back of the mouth, particularly along the gums and between the teeth, and in the top of the mouth. Shade in the hair colour, using the side of the pencil, then add the light shadow along the muzzle. Next, add the ends of the whiskers.*

4 *A combination of layered colours – here, blue, purple, red and grey – gives a better result for the depth of darkness in the mouth than going straight for black. Shape the lower jaw, strengthen the tongue colours, then add the whiskers, checking how each one curves.*

EARS

For the artist, ears are possibly the most challenging detail to capture successfully. First, they incorporate a number of different textures – the velvety down or long, perhaps curly hair on the outer surface and the smooth skin on the inside, the elaborate curves and folds and wispy hairs inside, not to mention tufts of hair. Second, some dogs have pricked-up ears, some long, drooping ones, while others have a combination of the two. Some ears are set high on the top of the head, while yet others start from well down on the side.

If you are lucky enough to observe a dog's ears with a strong light source behind them, you can draw the fascinating and intricate pattern of tiny red veins that are otherwise invisible.

ALL ANGLES
This mongrel's ears are a study in themselves, due to the angles at which they flop over and the differences between them. The nearer ear shows the fold and colours in the shadowed areas, while the light on the further one highlights the deep pink colour and the sensitive, wispy hairs.

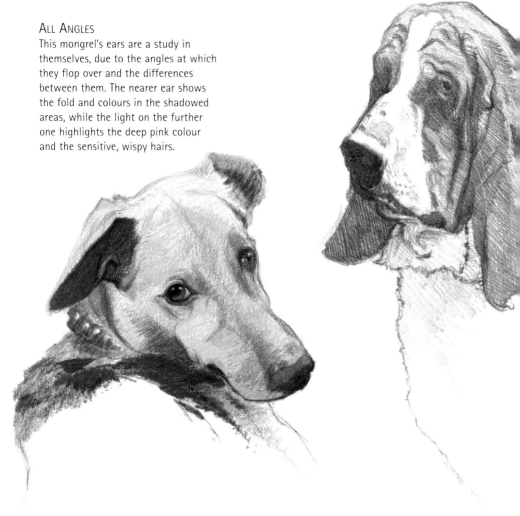

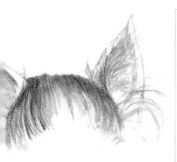

Drawing Ears

The large, forward-facing ears of a Siberian Husky are set high up on its head, showing the curve and hairs on the inside. I used coloured pencils for this study.

Prick Up Your Ears

Seen in isolation, this Yorkshire Terrier's ears look like they belong to a gremlin, not a dog. A 4B pencil and torchon created the shape, edges and contours of the ears and top of the head, then a little pink was added to show the depth of colour on the inside surface.

1 *Lightly sketch the top of the head between the ears; make small grid lines to find the proportions. Make tentative lines to construct these reference points, particularly between the tips to show the relative height.*

2 *Draw down the outside edges of the ears into the sides of the head, checking the angles. Work down the centre of the forehead, lightly adding the eyes and the markings above them to provide a context and position.*

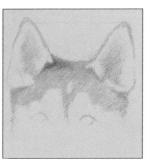

Drooping Ears

A Basset Hound's ears are longer than its head, and trail along the ground to trap scents and push them forward to the very sensitive nose. The outline and folds here were hatched and crosshatched using a series of medium-to-hard-grade pencils. Note the curve back at the very bottom.

3 *Still using the basic colour, use hatching strokes to define the darker areas, and show depth and recession in the curve inside the ears. Small strokes start the colouring at the edges and suggest the short, spiky fur. Overlay the fur colours.*

4 *With the coloured areas established, work across the whole drawing to darken and colour the tones. Although the ear tips are darkest, there are still red tufts. Use the paper for white highlights, and make light strokes far apart for the inner ear hairs.*

DRAWING THE WHOLE HEAD

The last few pages have looked at the main parts that go to make up a dog's head – the shape, proportions, dimensions and facial features. This exercise pulls these separate elements together to produce a head-and-neck portrait.

I chose the Weimaraner head opposite for a number of reasons: the short hair allows you to concentrate on the actual outline and contours; the quarter-profile pose means that you have to check the perspective to draw both eyes and nose accurately; and the colouring of this breed is particularly subtle.

Remember to build the elements across all the picture as you work, even if this might look like you are dodging around. It is only by a constant process of judging and changing that you are likely to achieve anything near a recognizable likeness.

OLD ENGLISH SHEEPDOG
This study is all about finding structure beneath a mass of hair that may not follow the contours underneath. The pastel strokes were built up from light to dark, with further light ones to reinforce the directions of the hair.

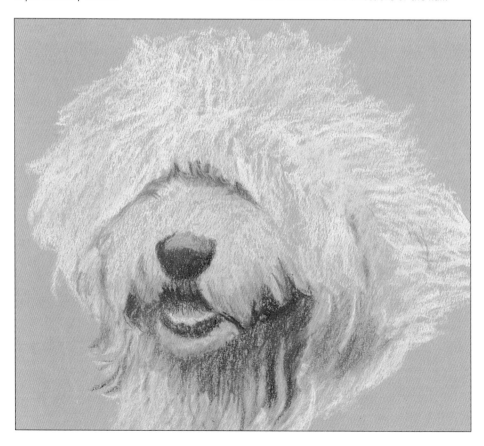

A Noble Pose

Using watercolour pencils gave me the choice of using them dry, to capture the shapes and build up the colours, or wet, for details and the strongest touches of colour.

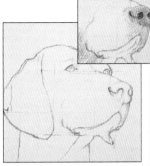

1 Sketch in the right eye, including the pupil and highlight. Use guide lines to find the eyebrow and ridge at the top of the head, and the other eye and top of the muzzle. Work the other way to find the inside edge of the ear.

2 As you continue to find the outlines and shapes, you need to check the proportions and dimensions, so work across the whole head. Draw part of the ear, then move across to develop the nose and jaw, then go back to the ear again.

3 Use guide lines for details, such as the mouth, jaw and whole ear. Look for characteristic shapes: the delicate fold on the outside of the ear is typical. **Inset:** The fold at the corner of the mouth joins into one of the neck cords.

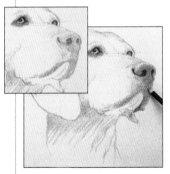

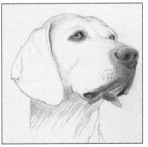

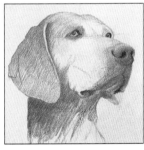

4 Build up light shadow lines on the neck and front of the muzzle. Add some delicate marks for the veins on the ears, and the details of the underside of the lower jaw. **Inset:** Add colour, beginning with the central eye and working outwards.

5 Strengthen the darkest colours of the mouth and jaw, using blues and browns initially, but checking to see if any other colours are present: here, reds and greys. Short, stabbed marks suggest the rough texture above the mouth, and the whisker ends.

6 Use a very light blue-grey for the contours that go over the muzzle and skull. Switch to gunmetal around the neck, then blend side strokes of brown across the whole head. Blue is good with grey for the ears, then darken their tone.

LEGS AND FEET

When it comes to drawing legs and feet, all too often they are treated as an after-thought – and the finished drawing suffers as a result. Regard them as important as hands and feet in a full-length human portrait, and make an effort to discover the structure beneath the covering, using contour, tone and colour.

Remember that dogs' legs and feet have been bred and developed for specific reasons over many generations, and are superbly adapted for these tasks: the claws of a Dachshund or terrier help the dog to dig out its prey, while a Greyhound's or Whippet's feet are aerodynamic and slim to help with speed. Water dogs such as the Newfoundland even have small webs between the toes, so observe and set down what is there.

THIN FRONT FOOT
For such a large dog, a Doberman Pinscher has a surprisingly slender front paw and foot. Even in this ballpoint sketch, it can be seen that the joints are clearly articulated under the skin, and that the claws extend well beyond the pads on the paws.

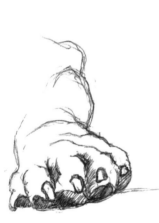
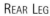

REAR LEG
Smooth-haired dogs are ideal subjects for observing muscle development in the rear legs. You can clearly see the prominent veins and the dramatic angle at the ankle in this Weimaraner leg; a little hatching and crosshatching suggest the contours and highlight the height and directions of the veins.

THICK FRONT FOOT
In contrast to the Doberman, the front foot of an English Bulldog is extremely wide. This type of foot is known as a 'cat foot' – but don't tell the dog that! – and is characterized by the spread of the toes and the width across. The claws do not reach the ground.

QUICK STUDIES

You are likely to get the chance to sketch paws and legs at the most inopportune moments, so it's worth building up a repertoire of marks with any drawing tool that comes to hand. The leg on the right is in pen and ink, while the leg on the left is in pencil.

COMPOSITION

This view of the front legs of a long-haired German Shepherd is technically interesting in a number of ways: the negative shape produced inside the legs helps to set the proportions; a build-up of pastels sets the colour and contours; and yellow and brown felt-tipped pens set the outlines and pull the study together.

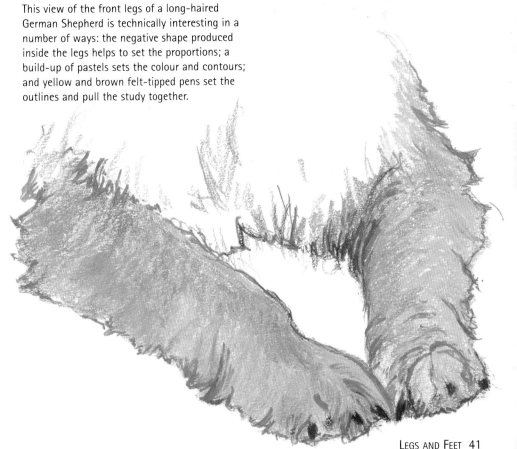

TAILS

A dog's tail is an indicator of its feelings, be it wagging with pleasure or tucked between the legs when the dog is being told off. In addition, no two tails are the same between breeds: colour, width, length, markings and kinks or curves all vary, while terms like 'flagpole' or 'sabre' are used to describe the way the tail is naturally held.

The studies here show tails in isolation and as part of the dog, and this can make or break a drawing – if the tail looks as if it was grafted on, the picture can fail. Look again at the anatomical drawings on pages 8–9, and see how the tail is an extension of the spine, then make your own studies with this knowledge in mind.

ENGLISH SETTER
The challenge with 'feathery' tails, such as on Setters, is to capture the long, flowing hair that falls from the tail while anchoring it in the solid bone and skin from which it is suspended. Build up the colours from light to dark, following the direction of the hair all the time.

FINNISH SPITZ
The tight curve and long hair on this tail make it into an almost abstract study, reminiscent of the shape of an orange maple leaf. Blending pastel pencils on the paper helps to create a depth of tone, from the lightest, most yellow hairs to the dark shadow areas nearest the tail's curl.

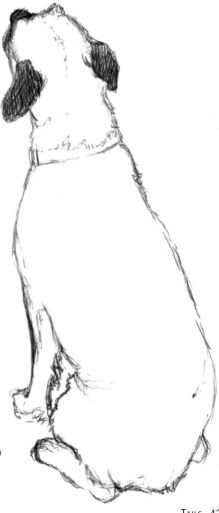

POINTER

Tails that are almost hairless need careful observation if they are not to look as if they are bits of rope attached to the dog's rump. The sleekness of this Pointer tail is emphasized by the light blue on the underside, which acts as a highlight against the black and light-pink markings.

GERMAN SHEPHERD

With this dog's tail resting on the grass, a torchon was used to blend the pastel and watercolour pencil markings so that the green surround mirrored the direction and movement of the hair on the tail. Used with discretion, this bringing together of subject and background can bring liveliness to any study.

SHORT TAIL

Even when a tail is docked or naturally stumpy, never assume that there is nothing to observe and draw. The way a short-tailed dog positions its rump when sitting is different to one with a tail, and a view from the rear shows this position best.

FUR, MARKINGS AND SKIN

Markings and fur texture are among dogs' most instantly recognizable and distinctive features. This section looks at long, short, wiry and curly fur, and shows you how to draw both the whole dog and how to sketch semi-abstract close-ups. It also looks at capturing bold and intricate markings, the range of colours, and taut and loose skin.

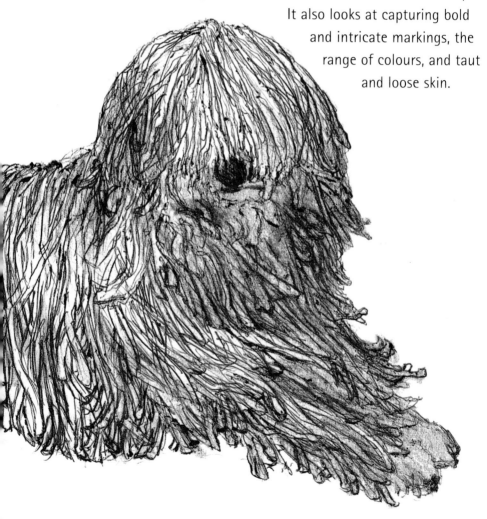

LONG-HAIRED DOGS

For the artist, the differences between long-haired and short-, curly- or wire-haired breeds are mostly seen in the techniques you use to delineate them, as can be seen over the next few pages.

Long hair tends to disguise the shape of the dog underneath, so your powers of observation are crucial. The roundness of a skull and the length of a neck may be invisible, and the entire body may disappear when long-haired breeds sit down. With even a small shift of viewpoint long hair creates any number of impossible angles and shapes, but it offers you the opportunity to use broader, more sweeping strokes to indicate hair direction than are possible with short-haired dogs or with the other varieties of coat.

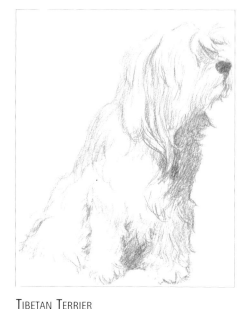

TIBETAN TERRIER
Certain kinds of long hair demand as loose a touch with the drawing tool as you can manage. The angles and direction of the hair combine with the stumpy legs and sketched rear end to create an every-which-way impression. Note the light shading below the jaw, which adds tone.

AFGHAN HOUND
The main shapes here were drawn with a torchon and graphite powder, building up from light to the darkest areas. You can't see the feet and leg structure at all, so capturing the contours of the hair is vital.

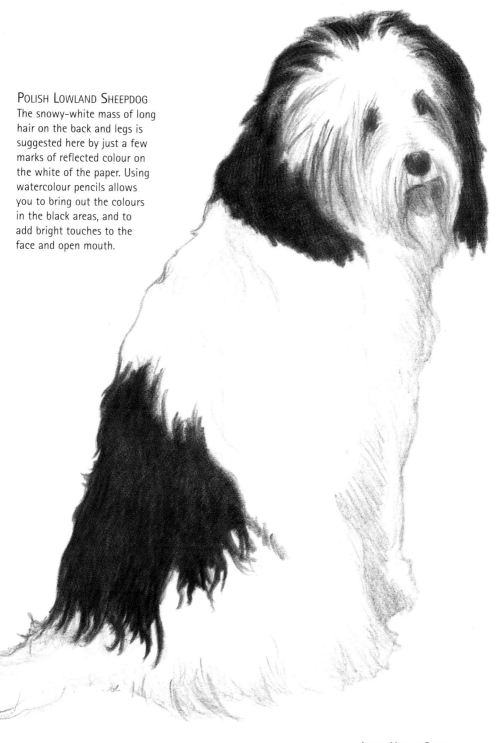

POLISH LOWLAND SHEEPDOG
The snowy-white mass of long hair on the back and legs is suggested here by just a few marks of reflected colour on the white of the paper. Using watercolour pencils allows you to bring out the colours in the black areas, and to add bright touches to the face and open mouth.

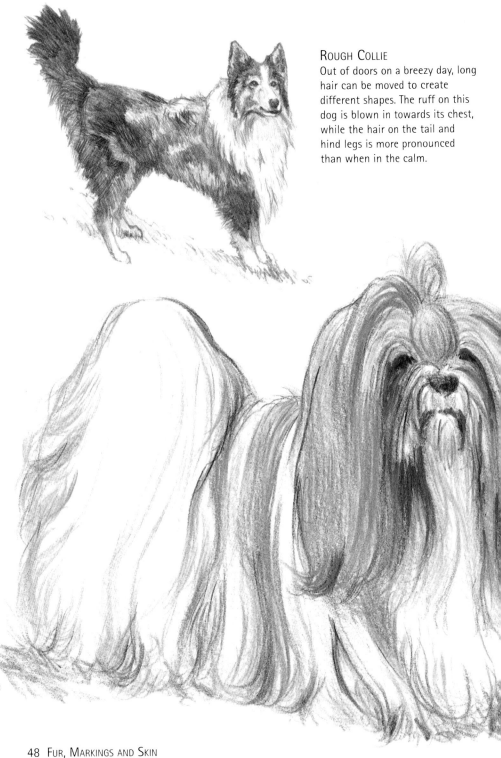

ROUGH COLLIE
Out of doors on a breezy day, long hair can be moved to create different shapes. The ruff on this dog is blown in towards its chest, while the hair on the tail and hind legs is more pronounced than when in the calm.

SHIH TZU

Once the shape has been established, the next choice is how much detail of the long hair to include. Here, the tail and rump are just lightly sketched in with watercolour pencils, while the sweep of the ear and facial hair uses a full range of colours, as does the topknot, which is essential for show dogs.

DRAWING LONG HAIR

The long coat of an Afghan Hound flows beautifully and reveals a myriad of different hair colours. I used pastel pencils to capture the black, white and tan shades here.

1 *Sketch the nose to establish a context, then mark in the longest prominent black hairs. Work lightly to set the basic strands; remember that the hairs do not all go one way. A few strokes of the lightest creamy colours help to fix the tonal limits.*

2 *In an isolated study like this, don't be put off if the drawing appears odd right now – persevere and draw what you see. Work across the drawing, adding black and light-coloured strokes. Use a torchon to soften the black, and to draw light-grey strokes.*

3 *Any 'tan' dog has a range of colours, and with long hair these are seen as strands or even blocks of colour. After making initial pastel marks for the longest and most prominent hairs, use the torchon to soften and draw them out as before, making long, even strokes.*

4 *As you add the fine strands, consider how to portray the white hair: light strokes of white pastel show where it overlays the darker colours, but leave the paper white for larger areas of white hair. Don't overwork the study, but look to keep the spontaneous feel.*

Short-Haired Dogs

It is possible to see the markings on short-haired dogs solely as solid blocks of different colours - you can get interesting results in this way, but you are likely to miss out on a great deal that can add subtlety and realism to your drawings. The close covering of fur allows you to see the mass of muscles under the skin - and with some breeds, you can see the bones of the back, shoulders and tail (see also page 66).

Using a limited colour range enables you to concentrate on the direction in which the hair lies and the shadows that are created as the skin beneath folds and creases or is stretched in different poses, as well as developing line and tone. At the same time, working with more than one colour gives you the opportunity to work on gradations in colour and even to exaggerate any apparent smoothness of texture.

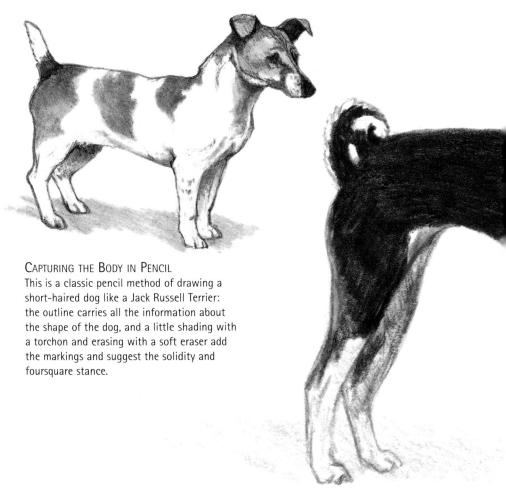

Capturing the Body in Pencil
This is a classic pencil method of drawing a short-haired dog like a Jack Russell Terrier: the outline carries all the information about the shape of the dog, and a little shading with a torchon and erasing with a soft eraser add the markings and suggest the solidity and foursquare stance.

SILENCE IS GOLDEN

The Basenji, the world's only breed of barkless dog, can only make a crooning sound. The long legs and high underbelly are emphasized by building up layers of watercolour pencil along the body, following the direction of the short hair.

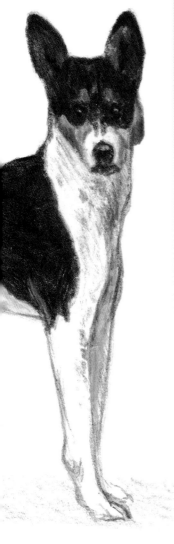

DRAWING SHORT HAIR

For this semi-abstract study of the short, shiny hair around the corners of a Doberman Pinscher's mouth I used watercolour pencils, ranging from raw sienna to ivory black.

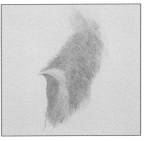

1 *Use long, light strokes of raw sienna to provide a base colour for the whole area, even those parts that will eventually be black. As a guide, darken where the folds and shadows are in the taut skin, using firmer marks of the base colour.*

2 *Switch to a golden brown to build up the subtle body colour. Look to capture the lights and darks, even where darker shades are to be put over the base. Use hatching to mark the contours of the skin and muscles, and the direction of the hairs.*

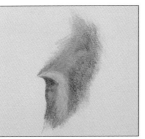

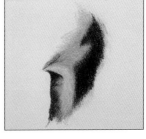

3 *Go over the whole area with a warm yellow, then use cadmium yellow to provide the texture of the short hairs. Orange reinforces the browny-red hues, while a purple indicates the borders of the darkest colours without having to use a more solid black too early.*

4 *Build up the black areas gradually, first with dark sepia over purple, then with purple again. Show the sheen on short black hair by using grey and purple, before you boost the most solid areas with ivory black, while still allowing the colours beneath to show through.*

Wire-Haired Dogs

If anything, capturing the unique qualities of wire-haired dogs is more difficult than for any other variation of hair. Unlike long hair, there is not the luxury of drawing long sweeps of hair (and losing feet and legs at times). Short hair is also easier, because you can look at the hair as a solid block of marking or colour and use it as a starting point for your drawing.

What you do get, however, is the chance to use whatever medium in short, stabbing marks, often to a far greater extent than you might imagine. Experiment by making quick sketches using everyday drawing tools such as ballpoints, felt-tipped pens or marker pens, and see how even random marks can be organized to put down on paper the chaotic nature of wiry hair.

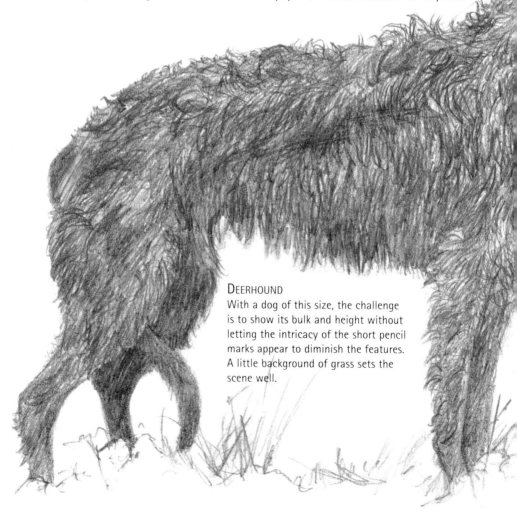

Deerhound
With a dog of this size, the challenge is to show its bulk and height without letting the intricacy of the short pencil marks appear to diminish the features. A little background of grass sets the scene well.

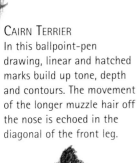

Cairn Terrier

In this ballpoint-pen drawing, linear and hatched marks build up tone, depth and contours. The movement of the longer muzzle hair off the nose is echoed in the diagonal of the front leg.

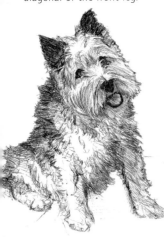

Drawing Wiry Hair

For this exercise I drew the hair of a wire-haired Pointing Griffon, or Czesky Fonsek, using watercolour pencils. The stone-coloured paper meant that I could use white pastels.

1 *Start by drawing over the whole area lightly and loosely with the lightest yellow (not white). Because wire hair grows every which way, don't make assumptions. Still working lightly, begin to define the darker areas with a light brown.*

2 *To warm the whole area up and link the light and dark hairs, add burnt sienna on top of both the base colours. A little burnt carmine can be added subtly, to pick out and frame the light colours that will not be covered by subsequent marks.*

3 *Make light strokes of umber to introduce the shorter tufts of wiry hair, placing them and framing the light areas. Note that the movement in this hair is less regular than in a curly-haired dog. Take your time when darkening, so that you have options right to the end.*

4 *Now introduce the white, again starting with tentative establishing marks and then strengthening them over the dark areas. Dip the white pencil into clean water to blend the white strokes, then do the same with the very darkest colours for an emphatic, opaque effect.*

CURLY-COATED DOGS

With the exception of poodles, you are less likely to see examples of curly-coated dogs outside a dog show than any other hair type. This is a pity, because some breeds' coats are unusual enough to challenge any artist's powers of technique!

What curly coats have in common with other types is the choice they give the artist as to how to faithfully show the curls without getting into the time-consuming and ultimately futile practice of trying to draw every single curl or area of curls. Here, as always, the medium is at least part of the message – using a hard, linear medium, such as pen and ink, ballpoint or hard pencil, produces very different results to those obtained with soft pastels, graphite powder or 9B pencils. Try drawing the same dog twice, using contrasting media.

STANDARD POODLE

The topiary-like shapes into which poodles' hair is cut allows you to look at different ways of drawing the breed. A combination of graphite powder, spread with a torchon, and pencils establishes the shape. A touch of pink and red for the mouth draws attention to the middle of the vast area of head hair.

BEDLINGTON TERRIER

The curly aspect of this dog is in the lamb-like tight curls on its head, which give it a unique appearance. Just a suggestion of the curls, as in this graphite and pencil drawing, can be enough to be convincing.

KOMODOR

Like its black-haired cousin the Puli, this Hungarian sheepdog's coat naturally forms into waterproof and warm curly cords – a canine version of dreadlocks. Ballpoint pen was used to draw in the cords, which were then overlaid lightly with coloured pencil.

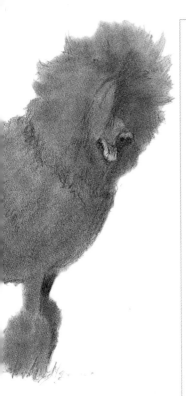

DRAWING CURLY HAIR

The curly coat on the ancient Barbet waterhound breed is waterproof. For a strong effect I used a range of dilutions of ink, applied with my finger and a pen, and marker pens.

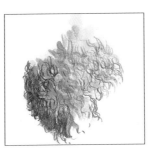

1 *Make up a pale dilution of ink and apply it with your finger – building up the drawing gradually. When this is dry, reinforce it with the same colour: long strokes suggest the fall of the curls, while slightly less diluted marks show the movement.*

2 *To show the darker areas, use full-strength ink on your finger. Then switch to a drawing pen, again with the full-strength ink, to find and point out the curliest areas. For variety, match these strokes with ones from a fine-tipped marker pen.*

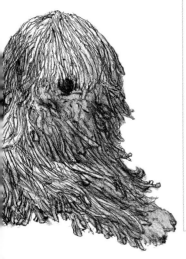

3 *Move across the whole base, initially with the drawing pen, concentrating on fixing the curls over the lightest areas of wash. Look out for the repeated patterns and shapes in curly hair, and switch between the dilutions, colours and pens to get the right effect.*

4 *Use the darkest marker pens to go over the drawing, remembering to leave the underlying washes and marks to show through where necessary. This defines the outermost curls, which are seen first. To finish, don't forget to draw the curled ends of the hairs.*

PATTERNS AND SPOTS

To start, it should be said that all dogs have markings of one sort or another: the coats of even completely white and black dogs produce patterns through shaded or more shadowed areas of fur; if they are long-haired, the fall of the fur creates creases and hollows; and short-haired dogs' muscles and bone structure create quite prominent shadows in different poses.

These pages concentrate, however, on the markings and spots produced by areas of different-coloured hairs. Take time when drawing or sketching patterns, as these are as much an indication of a dog's uniqueness as its facial features. As you try out different media, it soon becomes obvious that certain drawing tools are better for certain kinds of pattern than others.

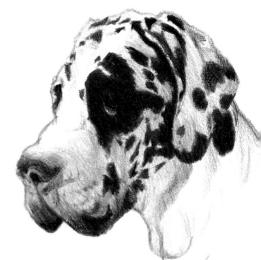

HARLEQUIN GREAT DANE
When confronted with something like a black patch over one eye, don't be tempted to draw what you think you see, otherwise caricature may result. Note also the reflected colours on the muzzle and neck.

STRIPES
Thin stripes are often seen on Whippets, as here, and Lurchers, and usually are darker versions of the underlying base hair colour. When drawing stripes, make sure that they are true to the contours of the dog's muscles and bone structure.

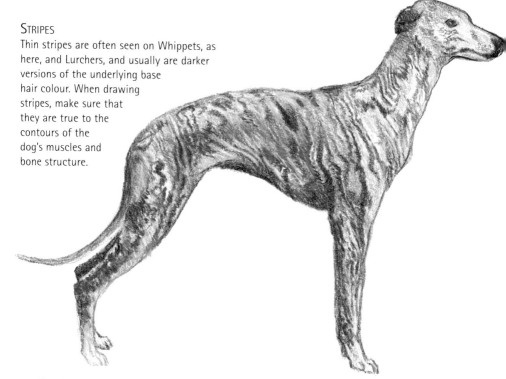

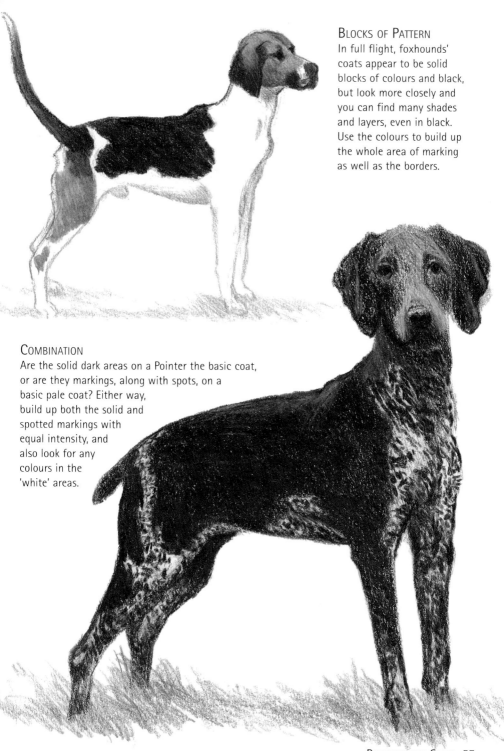

BLOCKS OF PATTERN
In full flight, foxhounds' coats appear to be solid blocks of colours and black, but look more closely and you can find many shades and layers, even in black. Use the colours to build up the whole area of marking as well as the borders.

COMBINATION
Are the solid dark areas on a Pointer the basic coat, or are they markings, along with spots, on a basic pale coat? Either way, build up both the solid and spotted markings with equal intensity, and also look for any colours in the 'white' areas.

Patterns and Spots in Pencil

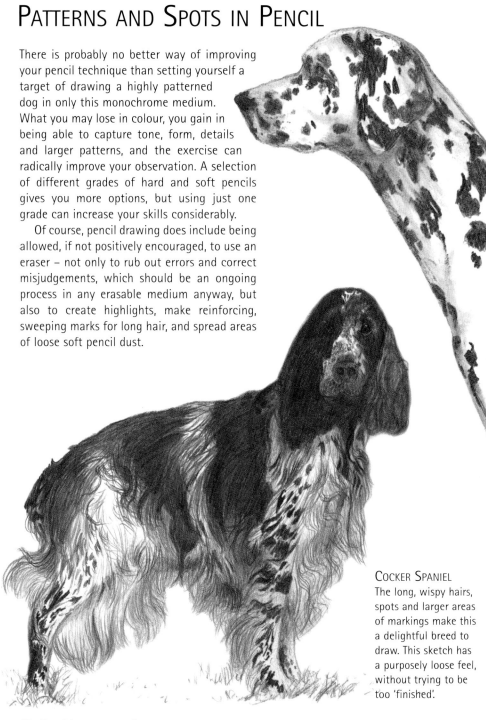

There is probably no better way of improving your pencil technique than setting yourself a target of drawing a highly patterned dog in only this monochrome medium. What you may lose in colour, you gain in being able to capture tone, form, details and larger patterns, and the exercise can radically improve your observation. A selection of different grades of hard and soft pencils gives you more options, but using just one grade can increase your skills considerably.

Of course, pencil drawing does include being allowed, if not positively encouraged, to use an eraser – not only to rub out errors and correct misjudgements, which should be an ongoing process in any erasable medium anyway, but also to create highlights, make reinforcing, sweeping marks for long hair, and spread areas of loose soft pencil dust.

Cocker Spaniel
The long, wispy hairs, spots and larger areas of markings make this a delightful breed to draw. This sketch has a purposely loose feel, without trying to be too 'finished'.

DALMATIAN
Dalmatians were very popular in Victorian
and Edwardian times as carriage dogs who
ran alongside smart horse-drawn vehicles.
In a pencil study, let the white of the paper
stand for most of the dog, making the spots
stand out. Not all spots are solid patterns –
look for where they fade into the white.

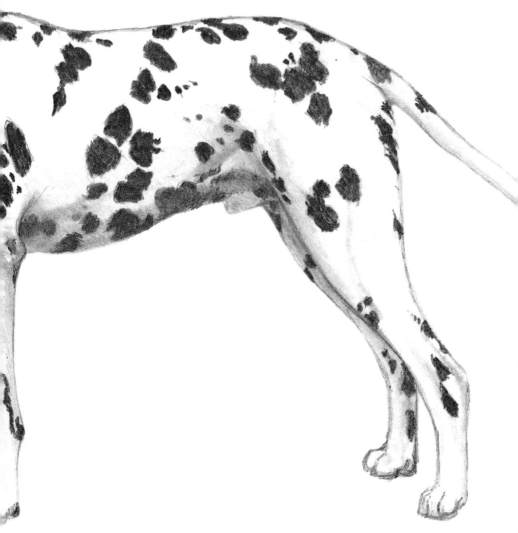

COLOURS

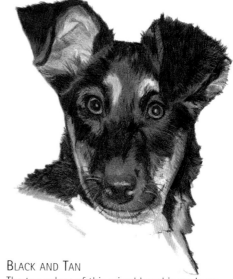

Not only do dogs have a greater variety of shapes and sizes than any other domestic mammal, but the sheer number and variety of colours in their coats also sets them apart – and gives you the chance to set these colours down in all their glory.

Even if you work from photographs and other reference materials, perhaps to draw dogs in action as in the fourth section of this book, make an effort to see the dog you want to draw in the flesh: even the most sophisticated colour reproductions cannot completely capture the subtlety and sheen of the real thing.

If you have the time, take a sketchbook and some coloured pencils and make colour notes on dogs you see, noting how some colours can be blended on the page, by hatching or crosshatching, for example.

BLACK AND TAN
The tan colour of this mixed breed is made up of a fair amount of olive green as well as the ochres, while the black has many purple-blue highlights. Draw what you see.

RETRIEVER
Like a New England wood in autumn, the colours in this sketch range from pale yellow to orange and burnt sienna, with the colours forming the contours above the eyes and along the muzzle. Make sure that the eye colour is accurate.

WEIMARANER

The 'liver' colour of these dogs is unmistakeable, but even this can change according to the light source. In warm light, the brown tinge is prominent, as in this watercolour pencil study, while in cold light, the coat appears predominantly grey.

SIBERIAN HUSKY

The colours on this breed run from strong on the top of the head and tail, to almost imperceptible along the flanks and on the legs. The white on the underside is a mixture of blue and purple.

DOBERMAN

In this sketch, both sharpened and blunted crayons were used. Note how the black areas have a great deal of reflected blue highlights, and the tan parts range from pale yellow to red, with the green of the grass also reflected in them.

BLACK DOGS AND WHITE DOGS

For the artist, there are no such things as completely black or white dogs.

Even the 'whitest' Poodles, Westies or Huskies can be seen by the artist as a riot of colours and gradations, among them reflected light from the ground, highlights, underfur and winter coats, and shadows as the fur moves in different directions off the skin. In addition, there are many white dogs that have a fair amount of colour in them as a matter of course.

The sheen and highlights on a short-haired black dog introduce colours, and the winter coat on a black dog is likely to be a variation of brown or chocolate with a grey-white undercoat (you notice this most in spring when the winter coat falls out).

BLACK AND WHITE
In this pencil study of a Border Collie, note how the blacks range from solid on the flank to charcoal grey on the head; and the white likewise varies, from the white of the paper above the nose to areas of very light grey, going even darker on the shadowed areas of the front legs.

DRAWING BLACK HAIR

To demonstrate that black hair can be made up of a multiplicity of colours, I used a variety of watercolour pencils to draw this American mongrel on white paper.

1 *The surroundings of grass reflect here onto the highlighted sheen. Apply the first base colour of cedar green, following the contours and the direction of the hair. Work lightly, hatching with short strokes, and indicate the shape of the darker areas.*

2 *Begin to build up from light to dark: go over the whole lightly with a dark brown, then again with a reddish brown, this time concentrating on the dark areas. Use ultramarine and Prussian blue to solidify these darkest patches.*

3 *Warm up the dark areas with crimson, adding very light touches to the lighter areas, then use a chocolate brown. A little Prussian blue offsets the crimson before you finally switch to black – to give extra depth while not obscuring the colours beneath.*

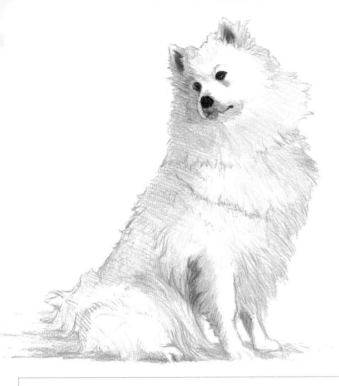

THE COLOURS OF WHITE
Only the face of this Spitz has been left pure white: elsewhere, purple, blue, yellow, black and green watercolour pencils are used to clearly demonstrate how reflected colours can predominate – yet the dog is still unmistakeably an overall white one.

DRAWING WHITE HAIR

The long hair of a Maremma, an Italian sheepdog also called an Abruzzi, is an ideal subject for a pastel study. I used quite a dark paper to bring out the pale colours.

1 Before putting pastel to paper, consider carefully just which colours go to make up the 'white', then use a light yellow-orange to establish the first strokes and lines of the hairs, concentrating on the flow and depth. Leave the dark areas for the time being.

2 Use French grey to fill in some of the gaps in the base colour, as well as going over some of the original orange. Work carefully – the grey has a bluish edge to it – and look for both the positive and negative shapes as you make the strokes.

3 Use umber for the outline of the darkest shapes, following their line and flow. Then apply white in places but not obscuring the other colours. A little black reinforces the brown lines, then add the loose white hairs on top and the blue highlights.

THE COMPLETE PICTURE

The preceding pages have concentrated on the details of patterns, spots and long, short, wiry and curly hair. This project looks at finding a context for all this knowledge, and bringing out the individuality of your subject through its markings and coat.

To do this effectively involves spending time just looking at the dog – which should be a pleasure rather than a chore – and observing how any markings and colours run across or along the contours of the body. Then you have to decide which angle is best for your purposes; remember that a straight-on front view may not always be the most telling one, and that a side view allows you to concentrate on the proportions. Take your time on a project of this nature, and don't be afraid to stand back and decide that a drawing may need to be started again from scratch.

THE STATE DOG OF LOUISIANA
Catahoula Hog (or Leopard) Dogs have short hair, well-defined patterns and spots, and a great range of colours in their coats, which can be best seen in a full profile stance. Even the blackest areas are made up of brown, purple and blue pencil layers.

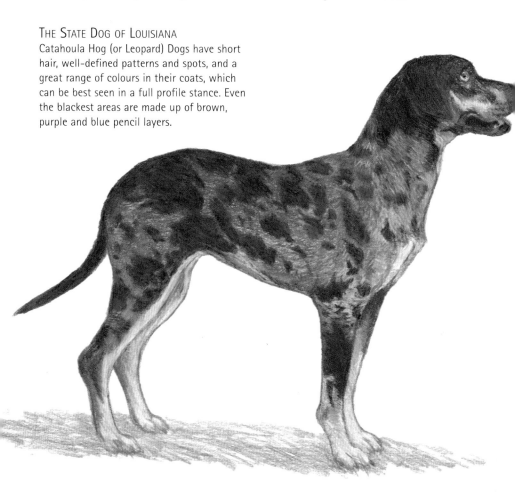

Combining Your Skills

Drawing a brindled Great Dane meant that I had to concentrate on the muscles and contours, and use a large enough piece of tinted paper! I used an HB pencil, torchon and graphite stick and powder.

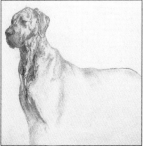

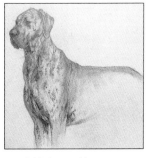

1 Work across the nose to the near eye, using guidelines, then add the top of the head, the line of the muzzle and the frown line between the eyes. Use the distances already established to add the nose, jowls and ear.

2 Add shading on the muzzle, then work down the neck, adding the largest creases, folds and shadows before reaching the broad chest. Use guidelines to start the shoulder and back. Work lightly and loosely.

3 Dip a torchon in graphite powder to shape the lower part of the chest and top of the front legs. Refine and define with light, then heavier pencil strokes. Use the torchon to add form and contours on the back, belly and chest.

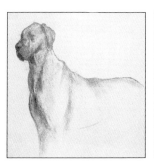

4 Use a wedge of soft eraser to pick out the highlights on the chest. When adding the markings, remember that their direction is influenced by the body – the muscles and bone structure. Carefully observe your subject to capture them accurately.

5 Continue to add the brindled marks and ticking – they are not just lines or dots, but a combination of the two. Work across the whole drawing, using the torchon and graphite powder to mark out and build up the contours and muscles.

6 Add the markings across the body and define the top of the legs further, checking that you are drawing what is there. Build up the chest and line of the tuck-up of the ribcage. Take your time, allowing yourself leeway to amend, even at this stage.

TAUT SKIN

Right at the beginning of this book, the importance of knowing something of canine anatomy was stressed. The dogs on these pages all have taut skin that serves to clearly reveal their basic form.

Because taut-skinned dogs are invariably short-haired, the tightness is seen in the shadows cast where the skin stretches over bones, muscles and veins. You can see the same shadow effect in the ears of standard and loose-skinned dogs, such as Bloodhounds and Weimaraners.

Build up the cast shadow areas as part of the structure of the whole drawing, not as a separate afterthought, and look for the colours and sheen on both the stretched and shadowed areas. A single-coloured dog is easy to portray in this way, but the challenge of drawing the same ribcage in both black and white is an exciting one.

CHIHUAHUA
The most striking effect of taut skin on these tiny dogs is on the face: whereas most other taut-skinned dogs have thin faces with long noses, here the skin is stretched tightly over the short, round skull.
Large, protruding black eyes and long ears contribute to the tautness.

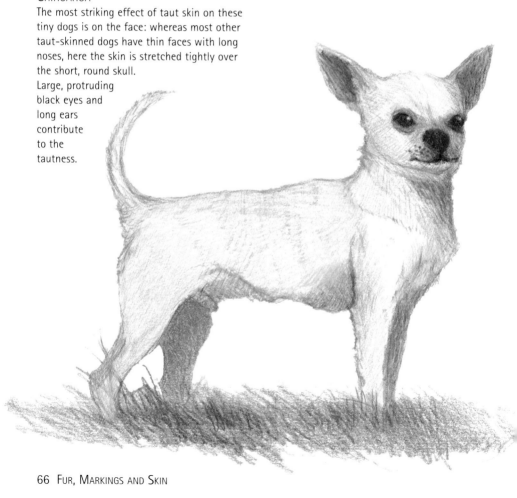

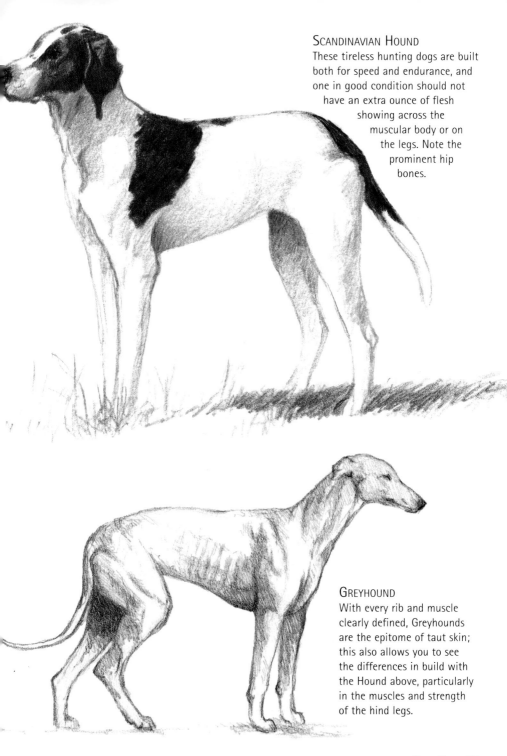

SCANDINAVIAN HOUND
These tireless hunting dogs are built both for speed and endurance, and one in good condition should not have an extra ounce of flesh showing across the muscular body or on the legs. Note the prominent hip bones.

GREYHOUND
With every rib and muscle clearly defined, Greyhounds are the epitome of taut skin; this also allows you to see the differences in build with the Hound above, particularly in the muscles and strength of the hind legs.

Loose Skin

In total contrast to the previous pages, you might think that dealing with loose-skinned dogs was an excuse to throw the anatomy lesson out of the window, and just to concentrate on drawing what you see.

It is hard to imagine the bone and muscle structure of a Shar Pei, but without giving at least a little serious thought to what's underneath the skin, you could easily end up drawing The World's Only Boneless Dog. Remember that there has to be something to hang all that skin on.

That said, folds and creases of loose skin can be great fun to study and sketch, as the angles are likely to be unexpected and demand your full observation. The outline of the dog may be unusual, too, especially when it is lying down.

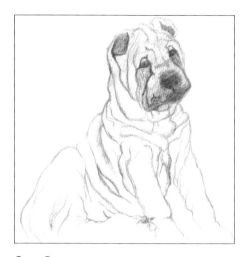

SHAR PEI
This watercolour pencil sketch concentrates on capturing the fantastic bagginess of the puppy's skin in purely linear terms; the marks are kept deliberately loose, to match the folds, and shadowing is kept to a minimum, to emphasize the effect.

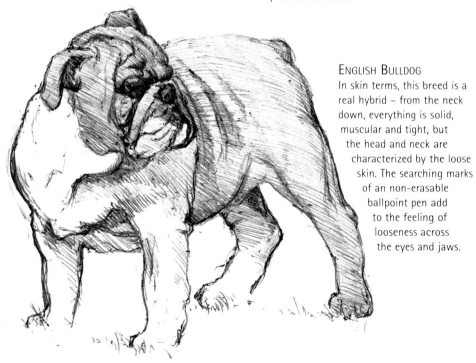

ENGLISH BULLDOG
In skin terms, this breed is a real hybrid – from the neck down, everything is solid, muscular and tight, but the head and neck are characterized by the loose skin. The searching marks of an non-erasable ballpoint pen add to the feeling of looseness across the eyes and jaws.

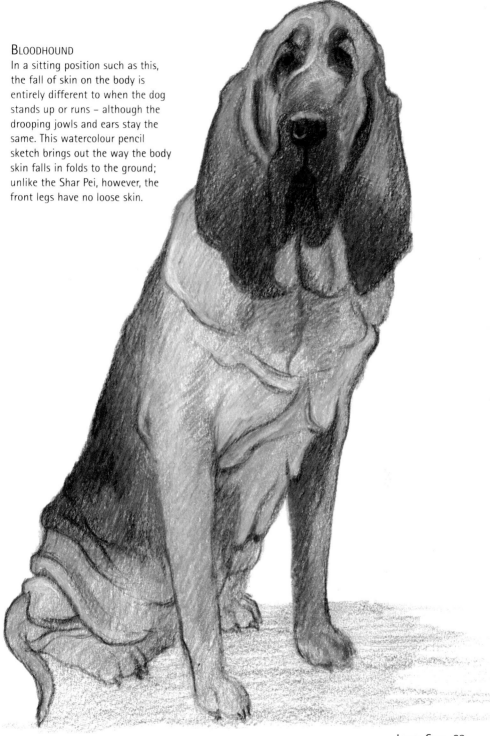

BLOODHOUND

In a sitting position such as this, the fall of skin on the body is entirely different to when the dog stands up or runs – although the drooping jowls and ears stay the same. This watercolour pencil sketch brings out the way the body skin falls in folds to the ground; unlike the Shar Pei, however, the front legs have no loose skin.

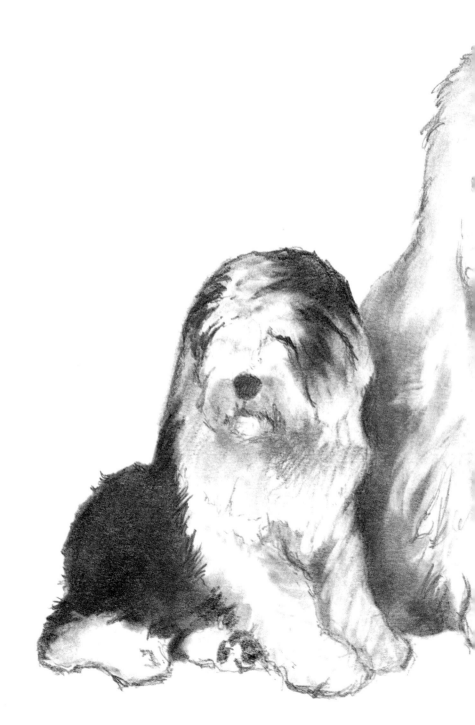

DOG POSES

Whether they are sleeping or racing about wildly, dogs are extremely rewarding to draw in context. This section puts together all the information from the previous ones, and looks at how you can set down what you see, both by direct observation and by using reference materials as aids.

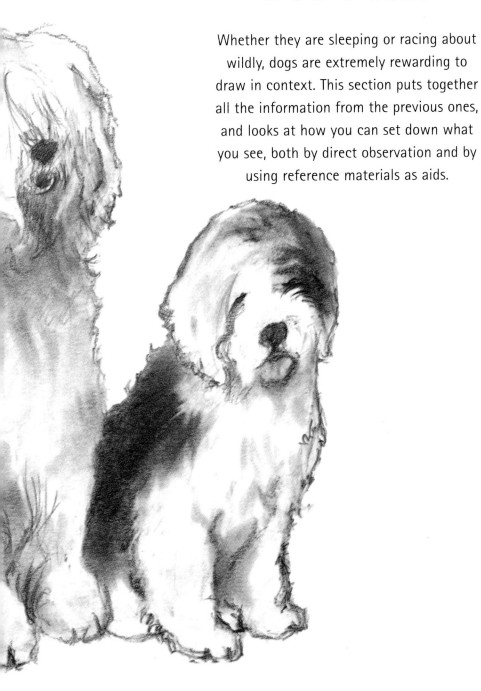

DOGS LYING DOWN

Sleeping or tired dogs make very good drawing subjects, if only because they may keep a pose long enough for you to get a lot down on paper. So have a quick medium, such as a pencil, and paper ready for work after a long walk – that is, if you still have the energy to draw!

Before starting, if possible spend a little time deciding on the angle from which you want to work. This can turn a pose from being a good one into a very good one. In the same way, think about what appeals to you most about the pose – the whole dog, or maybe one detail or part. Don't forget to include the setting where appropriate.

You may be lucky enough to finish a drawing before your subject decides to move – if not, just add the sketch to your collection and try to catch the pose again some other time.

RELAXATION AND ALERTNESS
Yorkshire Terriers are able to lie down and yet take in everything that is going on around them at the same time. In this water-colour pencil drawing, the droop of the head hair is echoed by the fall of the body hair to the ground, and the head colours are matched by those of the front and hind paws.

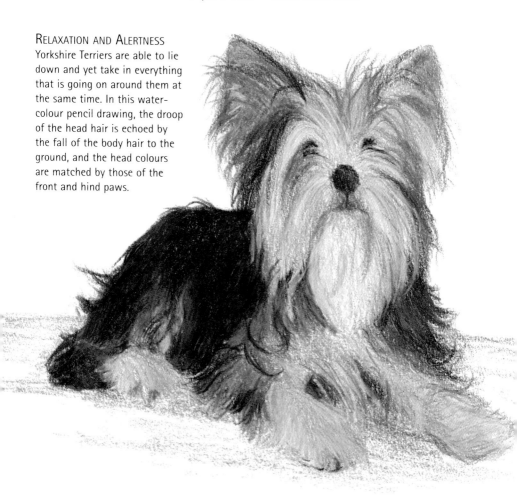

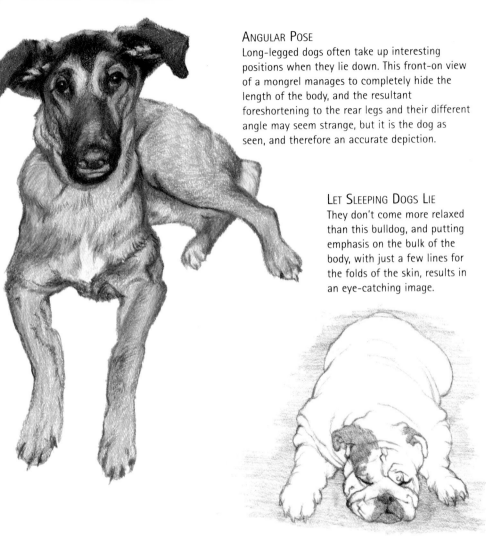

Angular Pose
Long-legged dogs often take up interesting positions when they lie down. This front-on view of a mongrel manages to completely hide the length of the body, and the resultant foreshortening to the rear legs and their different angle may seem strange, but it is the dog as seen, and therefore an accurate depiction.

Let Sleeping Dogs Lie
They don't come more relaxed than this bulldog, and putting emphasis on the bulk of the body, with just a few lines for the folds of the skin, results in an eye-catching image.

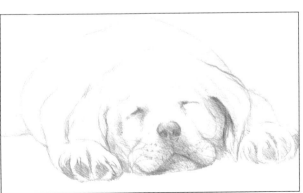

Finding a Level
At the right angle, the familiar sight of a sleeping dog can take on a new aspect – at floor level, the head and body look like ranges of hills, while the massive paws frame the head perfectly. A single raw umber watercolour pencil was used.

DOGS SITTING

When you observe a long-haired or loose-skinned dog in a sitting position, you may need to remind yourself that this is the same animal who, when walking, running or jumping, is all lithe muscles and sinews. When sitting the hair or skin of a dog may settle into a shape that bears little resemblance to the standing animal. The difference is not so marked in a short-hair, but it is still there.

The main things to look out for are the curve of the back and the way the head is held, the position of a long tail – curled round the feet, curved upwards or straight out – and the legs and feet: depending on the dog, the front legs may be quite far apart and bearing a lot of weight, or closer together, acting more as balancing units than supporting ones. Again, quick sketches are invaluable.

HIGH VIEWPOINT
This unusual angle focuses attention on the way this Border Terrier is sitting – in quite an upright position, with much of the weight seemingly taken on the front paws. Soft-grade pencils blended with a torchon gave the sketch a rich texture.

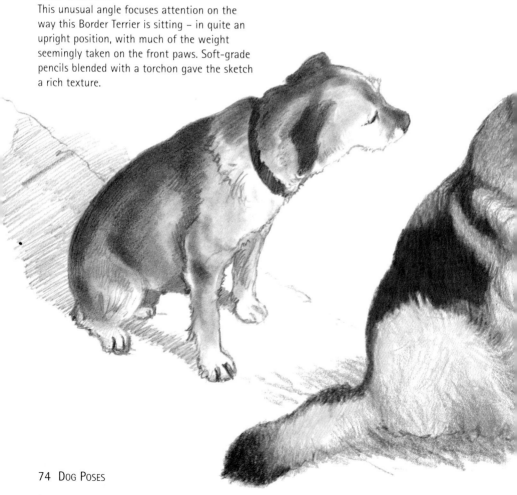

ALERT GERMAN SHEPHERD

Even when tired, a dog will sit down in readiness to leap to its feet. The keen focus in this dog's face is slightly at odds with the sitting pose, but it is exactly this kind of tension or incongruity that can add to a drawing.

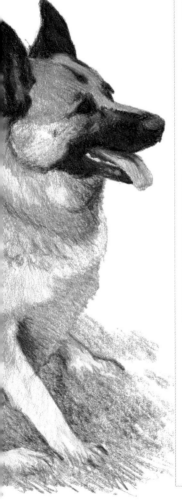

DRAWING A SITTING DOG

On sitting down, this Black and Tan Coonhound struck a pose with a silhouette-like quality, and I decided to use charcoal on tinted paper to emphasize the effect.

1 *Even though there won't be much detail in the sketch, start by drawing the near eye with a thin charcoal stick and finding the proportions of the head and neck from it – use guidelines as required.*

2 *Fix the position of the legs, using the head to check the proportions – there is a negative shape between the front legs. Add light guidelines and 'scaffolding' marks to see how the hind legs and tail relate to the rest.*

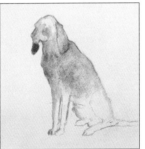

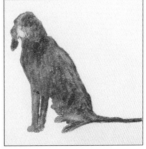

3 *Establish the lines of the hind leg and belly, then add the near ear. Snap off a small piece of charcoal and use the side to put a covering of dust across the body, and a heavier one on the ears. Spread the charcoal dust around with a torchon.*

4 *To capture the form, add light marks and spread them in from the outline, then build up and strengthen the darkest areas. Press the charcoal hard into the tooth of the paper, following the line and direction of the hair. Pick out light areas with an eraser.*

Dogs Stretching and Scratching

The poses that best show the suppleness and double-jointed qualities of dogs – from the largest to the smallest – are those when they are stretching and scratching.

A small dog can suddenly appear to be twice its length or height when stretching; even a short scratch of an ear can make the neck extend to odd lengths and curve the back to extraordinary angles.

This is where accurate observation and drawing what you see are invaluable: don't settle for following what you think should be the case – draw what you see however un-doglike or unlikely it may be. It is also worth using the first drawing implement that comes to hand, because the practice you get in setting down the poses – however they turn out – cannot be duplicated.

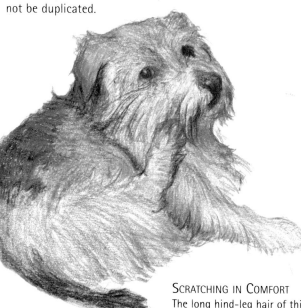

Scratching in Comfort
The long hind-leg hair of this terrier makes it seem as though the scratching foot appears out of nowhere – but the angle and curve of the back are accurately drawn, so the pose is a credible one.

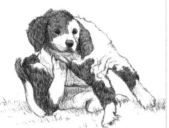

DRAWING A STRETCHING DOG

This pose, which shows a Rottweiler bitch resting her front paws on a wall, is all about balance. I used ballpoint and rollerball pens on smooth cartridge paper.

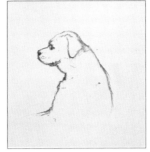

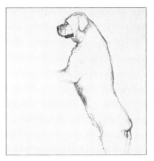

BALANCING ACT

In its eagerness to get a good scratch, this puppy's weight is all pushed towards the scratching hind foot, resulting in a position that is full of tension and pressure. Using short strokes with a ballpoint pen adds to the direction in the pose.

1 *Sketch in the eye, nose, forehead and jowls, working carefully because ballpoint marks are permanent. Move across and down – the proportions in this pose will be different to when the dog is standing.*

2 *Drawing the front legs and belly, use a light touch so that shading and hatching marks describe both contour and form. Work gently to find the lower body and hind legs, checking that the balance of the pose is accurate.*

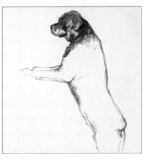

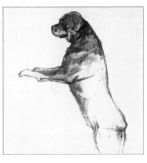

AT FULL STRETCH

During training for guard work, this German Shepherd adopts a stretched pose. Here you can see the length of the body without being distracted by the low hindquarters of the standing position; note how the front legs are used for balance.

3 *Start to build up the tones and shading on the head, first with the ballpoint and then reinforcing with the rollerball. Keep the lines following the fur, and look for highlights in the coat. The front legs must be resting on something, not in empty air.*

4 *Every part of the dog is involved in stretching and balancing, so as you work across the body, keep checking against what you see. Alternate the tight lines on the detailed areas with looser ones to give a brief description of the lightest parts.*

DIGGING, GNAWING AND CARRYING

Given half a chance, any dog will enjoy digging – to bury or unearth a bone, or just for enjoyment. You can often catch them gnawing on a bone and they also love to fetch and carry – anything from a pebble or toy to a piece of driftwood twice their size.

With luck your subject may be absorbed in its task long enough to allow you to make quick sketches that encapsulate just what the activity is all about. At the same time, don't forget to look out for the details that count – the angle of the front paws when the dog is digging, or the angle of the head when carrying an object, particularly a bulky or heavy one.

Although fetching and carrying are prime examples for using photographs or other reference materials, make sure you back any pose up by direct observation.

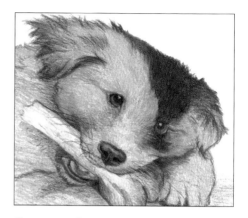

PUPPY WITH BONE
Even small puppies try to carry and gnaw large bones. This contrast in sizes is a good subject, so long as you don't exaggerate it.

DIGGING FOR TREASURE
It is the intensity of the pose in this pencil and torchon sketch that immediately draws the eye: every part of the dog is focused on what is just below the topsoil. Note the degree to which the front and head have sunk, compared to the normally positioned hindquarters.

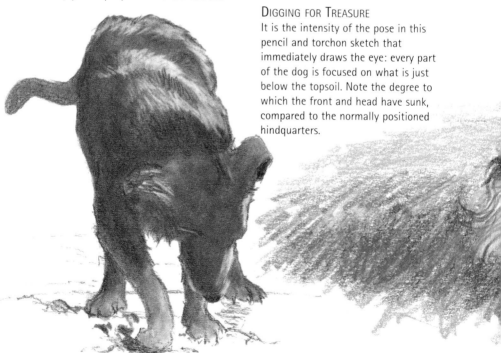

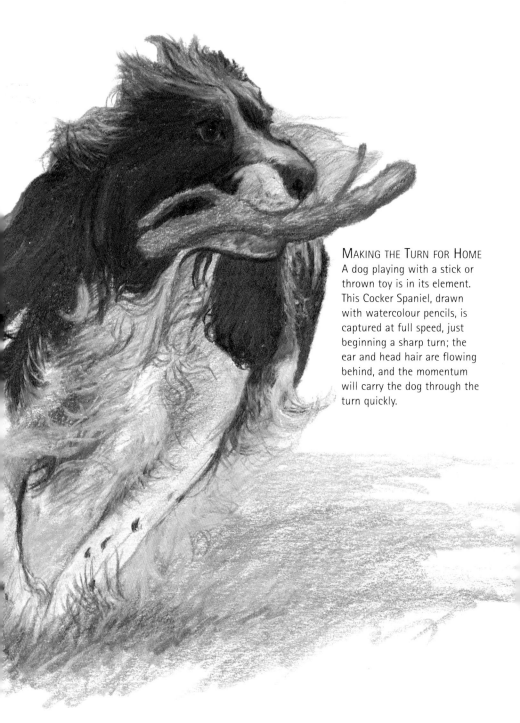

MAKING THE TURN FOR HOME
A dog playing with a stick or thrown toy is in its element. This Cocker Spaniel, drawn with watercolour pencils, is captured at full speed, just beginning a sharp turn; the ear and head hair are flowing behind, and the momentum will carry the dog through the turn quickly.

Working Dogs

Since the first domestic dogs appeared on the scene, dogs have been trained for working with people. Many show or currently non-working dogs are descended from breeds originally bred for work – for instance, Dachshunds were first developed in order to catch badgers.

Drawing working dogs is the ideal opportunity for you to include more contextual information than is needed in individual studies: even very sketchy outlines play a part in setting the scene.

It is possible to work on location on farmland or private land, provided you ask the dog's owner beforehand if he or she minds you making sketches and drawings. Whatever the site, don't distract the dog from doing its job properly.

Guide Dog
Particularly in crowded, busy urban environments, guide dogs have to be their owners' eyes, as well as being watchful at all times. Even in a quick sketch, look to indicate the close bond that invariably grows up between dog and human.

Pointer
This is the archetypal pointing pose, and a pleasure for the artist. Look at the similar angles of three legs and the odd one out, and make sure that the angle and height of the tail are correct.

GUN DOG

Labradors and other gun dogs are trained
to bring back often large birds and game
without damaging them in transit. This
ballpoint sketch concentrates on the angle
of the head and the balancing tail.

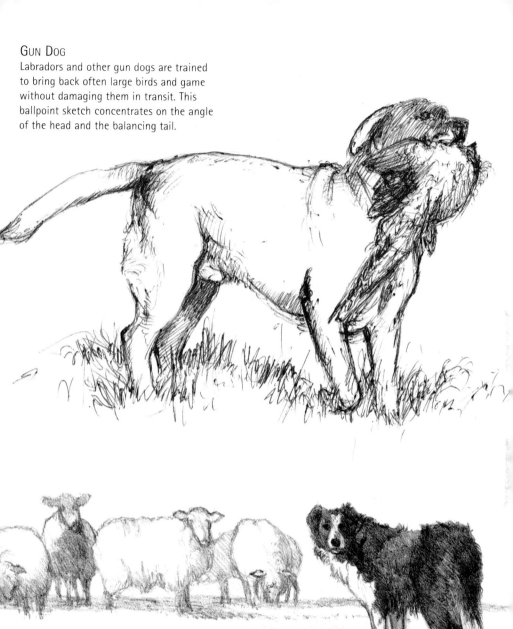

SHEEPDOG

A working sheepdog is always on the
alert, ready to round up any stray sheep
and respond to its owner's whistle.
Include a few quick sketches of sheep,
both to set a context and show the size
of the dog relative to its wards.

Dogs Walking

Depending on whether the walk is for hygiene, pleasure or business, the way a dog walks can be anything from a gentle amble to the tense, alert gait of a hunting or gun dog. In addition, there are a number of walking speeds, all of which come to affect the pose.

Capturing all this is down to a combination of acute observation and quick sketches, and using reference materials such as photographs. In the former, even if all you get is the head and part of the front legs, this can be invaluable when you make a composite drawing based on sketches and studies; so look for the angle of the hips and back, and position of the legs.

If you can, ask a family member or friend to walk a dog up and down before you while you make sketches and sort out tricky parts – but don't work the dog for too long.

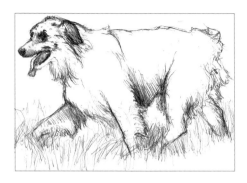

In the Grasslands
Where long grass hides a dog's feet, make sure that you have observed the pose properly. If not you may end up with a dog that is either floating over the ground or appearing to be completely off-balance.

High and Handsome
The haughty carriage of an Afghan Hound is a delight to observe and to draw. This ballpoint sketch captures the long strides, curve of the front leg and curled-over tail, using long strokes of the pen to suggest the long hair.

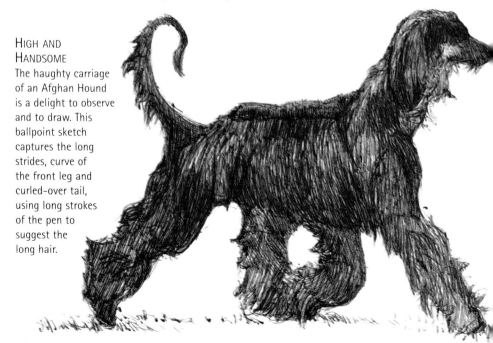

DRAWING A WALKING DOG

I chose this unusual view of an English Bulldog because it emphasizes the build and loose skin, and drew it with graphite powder, 6B graphite stick, pencil, torchon and brush.

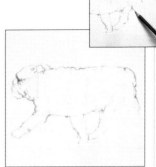

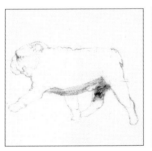

1 Use a pencil to lightly place the eye and the front of the head, adding the basic folds of loose skin, which also act as guidelines. Move down the neck to the chest and short, stubby leg and large front paw, sketching in any folds and creases.

2 Work on the top of the head, concentrating on the folds and flap of the ear, then move on to the back (the neck is very short), taking in the folds and creases of skin. Use dotted lines to set the proportions of the back and almost imperceptible tail.

3 From the near front leg, use guidelines for the proportions of the chest and far front leg, then move up the belly towards the hind legs – note the negative shape between them. Inset: A mark from the tail sets a triangle where the hind legs meet.

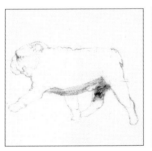

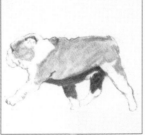

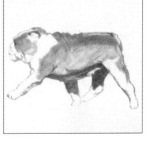

4 Add the hind legs, looking across the whole drawing to find reference points; in this pose, the paws don't all finish on the same plane. For shadow areas, dip a soft brush into graphite powder and apply it, then blow off the excess when in position.

5 Define the markings lightly, blowing off the excess as before. Dip a large torchon into the powder and use it to draw the head markings, and then reinforce the markings and shadows across the dog. Add the contours and folds.

6 Use a sharp pencil to define the edges of the dark areas, and pick out the underbelly with a sharp wedge of eraser. Solidify the legs and paws with light shading, defined in pencil, and use the same technique for head details and folds of skin.

Dogs Running

I see you stand like greyhounds in the slips./Straining upon the start.

King Henry V, Shakespeare

Dogs are often evoked in literature and the sight of a dog running is exciting and graceful in equal measure. Getting good reference material is not always easy, and it's worth spending time taking your own photographs of dogs running or finding images to study in magazines or books.

The drawings on these pages show how varied the results of using different media can be. Experience and experimentation bring their own rewards; for the most part, the more detailed a drawing of a running dog, the more static the final drawing. Try to capture the energy of the pose, rather than setting down every muscle or hair.

Full Speed
A Vandyke-brown crayon is a good medium for drawing a speeding Whippet, as you have to concentrate on the essential angle of the pose, without unnecessary details.

Dog on the Run
For dogs with such short legs, Dachshunds can get up a surprising turn of speed, and at full stretch their athleticism is apparent. This ballpoint sketch was made to catch the pose – note the very straight back and flying hind legs – and so only the front of the dog has any detail, adding to the feeling of speed.

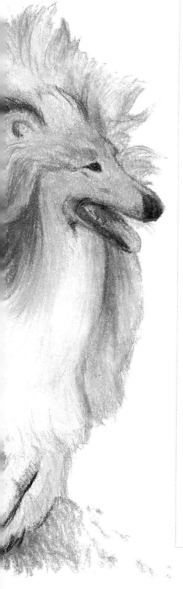

FRONT VIEW

You can tell that this is a running, not a walking pose – the hind leg is close to the front one, the ears and long facial hair are blown back, and the balancing tail is held high. Pastels and water colour pencils captured this pose.

DRAWING A RUNNING DOG

Even when using photographs as reference, back them up with quick, if unfinished, sketches. I used a rollerball, a very quick medium, to capture the movement of this crossbreed as it got into its stride.

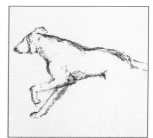

1 *Make tentative marks to establish the shape of the head and ear, using any markings as guides – these first marks can emphasize the motion. Use the head and ear to find the proportions of the back and front leg, which is not supporting the body.*

2 *Look carefully at both front legs, noting the negative shape between them, before committing yourself to setting them down. Use a little loose hatching to show shadow and strengthen the line of the back, and ensure that the tail is set correctly.*

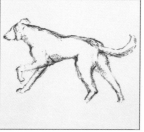

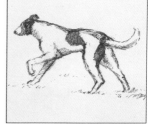

3 *The near hind leg is ready to push forward, while the far one is already at full extent, so their proportions are different from when the dog is at rest. Work across the whole drawing, amending where necessary and suggesting the contours with light marks.*

4 *Use layers of hatching to position and establish any markings, and as you strengthen them, continue to lightly build up the lines, contours and form. You only need to sketch in the surface on which the dog is running, but this should be added!*

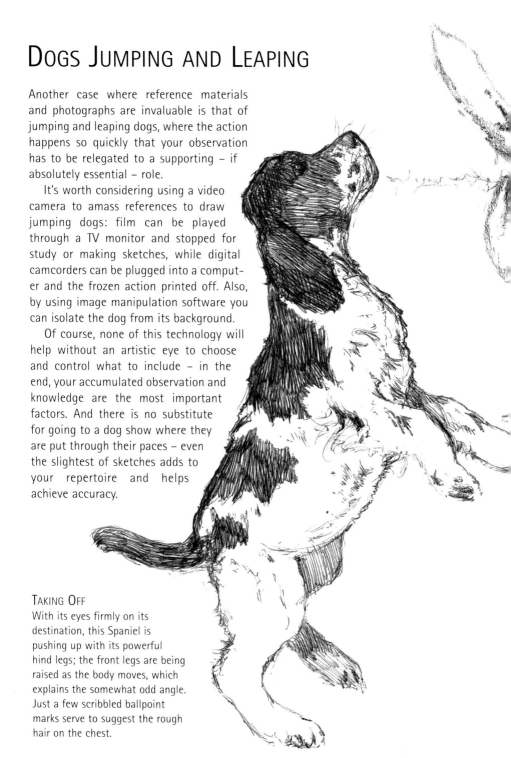

DOGS JUMPING AND LEAPING

Another case where reference materials and photographs are invaluable is that of jumping and leaping dogs, where the action happens so quickly that your observation has to be relegated to a supporting – if absolutely essential – role.

It's worth considering using a video camera to amass references to draw jumping dogs: film can be played through a TV monitor and stopped for study or making sketches, while digital camcorders can be plugged into a computer and the frozen action printed off. Also, by using image manipulation software you can isolate the dog from its background.

Of course, none of this technology will help without an artistic eye to choose and control what to include – in the end, your accumulated observation and knowledge are the most important factors. And there is no substitute for going to a dog show where they are put through their paces – even the slightest of sketches adds to your repertoire and helps achieve accuracy.

TAKING OFF
With its eyes firmly on its destination, this Spaniel is pushing up with its powerful hind legs; the front legs are being raised as the body moves, which explains the somewhat odd angle. Just a few scribbled ballpoint marks serve to suggest the rough hair on the chest.

DRAWING A LEAPING DOG

Captured in mid-leap, this German Shepherd cross is elongated in some parts but not others. I used pencils and watercolour pencils on tinted paper that matched the colour of the dog.

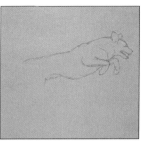

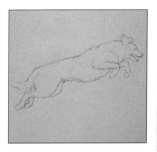

1 *Working backwards from the eye and nose, lightly sketch in the outline. Some parts may seem unusual due to effort and concentration – the position of the ears, the thickness of the neck and the length of the front legs – but draw accurately what you see.*

2 *Move down the back to the tail and powerful legs at full stretch, remembering that they are not supporting the body. Indicate the rough hair as you fix the outline, and pay attention to the complex positive and negative shapes of the legs and feet.*

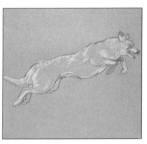

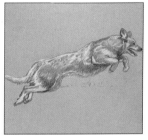

3 *With the outline fixed, add first a light covering of pale mist, then some light brown to establish the various areas. Add the palest sections next, including pink, working slightly overlarge so that you can get a blend with subsequent laid-on colours.*

4 *Use colours to set the form: brown along the neck, blue-grey on the face, neck and shoulders, and gunmetal on the body. Always follow the direction of the fur, and use it to accentuate the power of the pose. Add a little crimson on the tongue.*

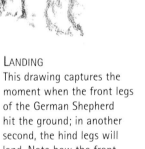

LANDING
This drawing captures the moment when the front legs of the German Shepherd hit the ground; in another second, the hind legs will land. Note how the front legs and chest take the strain and slow down the momentum, and observe how the tail is held horizontally.

Dogs Together

'I am His Majesty's dog at Kew,/Pray tell me, Sir, whose dog are you?'

So ran the inscription on the collars of King Charles II's Spaniels in the seventeenth century, a sweet suggestion that dogs speak to one another. Dogs are naturally gregarious creatures and this can end up with them playing together or engaging in a standoff or full-scale fight. Just take your sketchbook and pencils to a local park for instant results.

You can choose to draw contrasting dogs – an Irish Wolfhound with a Jack Russell Terrier would be an entertaining, if extreme, combination – or dogs from the same family or breed. Experiment with using different media for each dog if you like, but remember that simplicity is a good way to begin.

Welsh Springer Spaniels
Dogs with similar markings pose a challenge; you need to show that they are of the same breed while retaining their individuality. The negative white markings help to set the proportions.

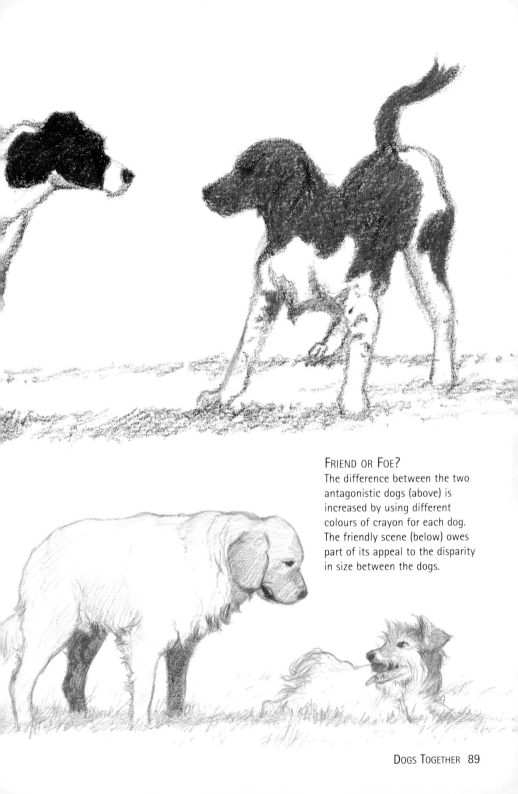

Friend or Foe?

The difference between the two antagonistic dogs (above) is increased by using different colours of crayon for each dog. The friendly scene (below) owes part of its appeal to the disparity in size between the dogs.

Mother Dog and Puppies

Puppy proportions were examined back in the first section, and the drawings on this page reinforce the examples there and also show the link between a mother dog and her puppies, which lasts until the young are comparatively grown, particularly if they continue to live in the same house.

Right from the earliest days after birth, you can find opportunities to draw mother dogs and puppies – but beware of getting too close, as even the most docile dog can feel threatened and want to protect her young. As the puppies develop, the drawing chances increase and can provide a visual diary of a growing family.

Another source of interest is seeing how long it takes for the puppies to resemble the mother; this is usually down to a long or curly coat developing into maturity, as short and wiry coats tend to be the same at birth as when the puppies grow up.

Old English Sheepdog
Their feet and legs may be proportionally as large as their mother's, but these puppies have yet to grow their breed's characteristic fringe. A wedge was cut from a soft eraser and used to make the wavy white highlights on the heads and chests of all three dogs.

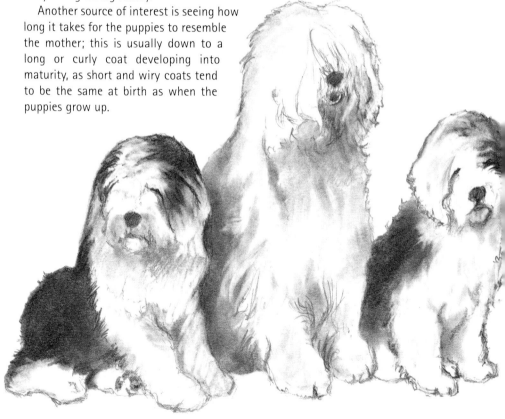

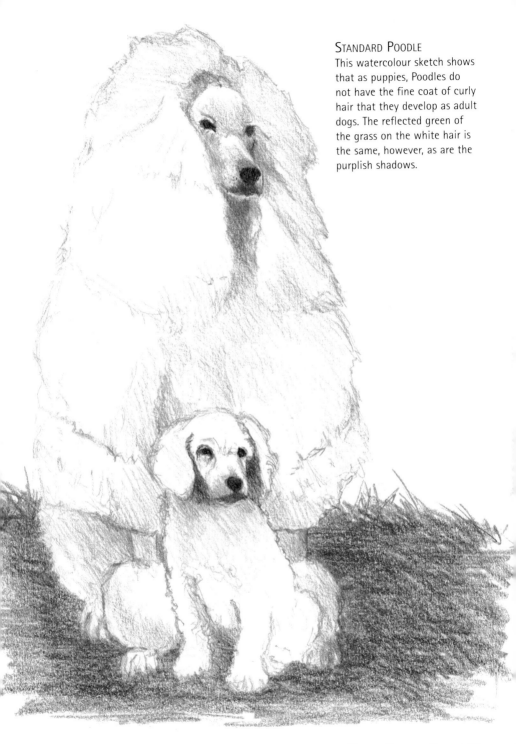

STANDARD POODLE
This watercolour sketch shows that as puppies, Poodles do not have the fine coat of curly hair that they develop as adult dogs. The reflected green of the grass on the white hair is the same, however, as are the purplish shadows.

PUPPIES

Few people can resist the charm of puppies of any breed, and good drawings of them are always looked at with interest. The problem can be capturing a pupy in order to make those drawings in the first place!

Puppies want to be everywhere and involved in everything, and so you may need to resort to photographs for specific poses, backed up by patient observation. If you can find a large litter of puppies to draw, so much the better – with similar shapes and sizes all around, you have a good chance of getting down at least semi-complete poses. And remember that a good part of the charm is the ungainliness as puppies struggle to grow into their over-sized limbs, so don't try to find the perfect pose, but draw what is in front of you.

LABRADOR
The contrast between puppies' ungainly bodies and serious expressions is captured in this pen sketch. The mass of the body is emphasized by leaving most of the pale coat unmarked.

BORDER COLLIE
Even with button eyes and floppy ears, this puppy already has longish legs. All the tones were built up by repeated hatching and crosshatching with a standard disposable ballpoint pen.

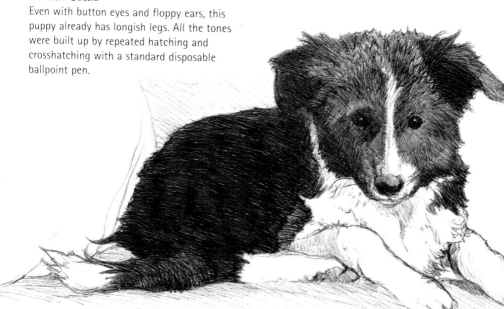

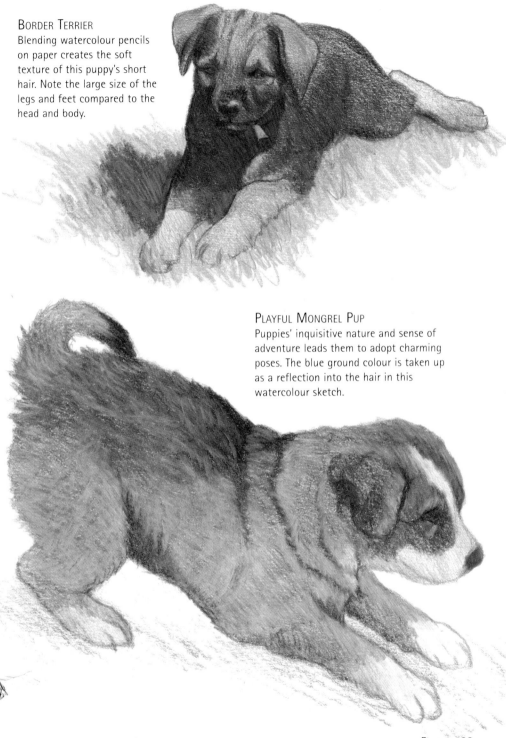

BORDER TERRIER
Blending watercolour pencils on paper creates the soft texture of this puppy's short hair. Note the large size of the legs and feet compared to the head and body.

PLAYFUL MONGREL PUP
Puppies' inquisitive nature and sense of adventure leads them to adopt charming poses. The blue ground colour is taken up as a reflection into the hair in this watercolour sketch.

INDEX

Acknowledgements

I'd like to thank the following people whose dogs were used as models in this book: Ann and Peter Crooks, Rob and Karen Wilson, June Lumbard, Glen and Margaret Paxton, Anne and Jack Williams, Jane Mawer, Celia and Ken Smith, Lincs., Paula Volkes, Frankie and Katie Thompson, Julie and Steve Josephs, Ian and Sally Crofton, Colin Elliott at Blade Security, Caroline Juler, Kate Macphee, Ms Elena and Mrs Michela Gianni, Lynne Brown and Duffy, Jacqui and Harry Currie, and James Baxter and Cassie.

A special thanks to George Taylor and Sarah Hickey for all their help with photographing the step-by-step sequences, and to Ian Kearey for his expertise. Also, many thanks to all the staff at Collins & Brown who, once again, helped produce this book with kindness and enthusiasm.